NICOTEXT

BLA BLA

Fredrik Colting
Carl-Johan Gadd
Edited by: Phillip Nakov

Copyright © 2007 by NICOTEXT AB
All rights reserved. No part of this book may be reproduced in
any form without written permission from the publisher.

The publisher, authors disclaim any liability that may result
from the use of the information contained in this book.
All the information in this book comes directly from experts but we
do not guarantee that the information contained herein is complete
or accurate.

This is the author's opinion, not necessarily
that of NICOTEXT or / and it's partners / collaborations.

©2007 NICOTEXT part of Cladd media Ltd.

www.nicotext.com
info@nicotext.com

Printed in the USA

ISBN 91-974882-1-6

Foreword

ALL THE FACTS IN THIS BOOK ARE ABSOLUTELY, AND WITHOUT A DOUBT TRUE. IN THE SECRET LABORATORIES OF NICOTEXT, JUST OUTSIDE GENEVA, MYSTICAL SCIENTISTS IN BLACK SUITS SCIENTIFICALLY TESTED EACH OF THESE FACTS.

IF SOMETHING IN THIS BOOK, CONTRARY TO OUR EXPECTATIONS, TURNS OUT TO BE FALSE, NICOTEXT'S ASTUTE SCIENTISTS WILL OF COURSE RECEIVE THE HONOUR OF BRINGING FORTH THEIR SCIENTIFIC DATA ON THE SUBJECT IN QUESTION.

SO, TO ALL OF YOU SAYING **"HMMM"**... CAN THIS REALLY BE TRUE?

YES, IT CAN!

www.nicotext.com

THE WALKMAN WAS FIRST
INTRODUCED IN 1979.

THE FIRST OWNER OF THE MARLBORO
COMPANY DIED OF LUNG CANCER.

THERE ARE MORE THAN 500 GIVEN
PHOBIAS. ONE OF THE RAREST IS
HOPLOPHOBIA –
A FEAR OF FIREARMS.

THERE ARE MORE THAN 17,000
AIRPLANES IN THE WORLD, OF WHICH
4,000 ARE ALWAYS AIRBORNE.

90 % OF THE CAB DRIVERS IN
NEW YORK ARE RECENTLY LANDED
IMMIGRANTS.

MADAGASCAR, OFF THE
EASTERN COAST OF AFRICA, IS
THE FOURTH LARGEST ISLAND IN
THE WORLD.

CHARLES BRONSON'S GIVEN NAME
AT BIRTH WAS CHARLES BUCHINSKY.
ERIC CLAPTON'S WAS PATRICK CLAPP.

THE WORD "AMATEUR" COMES FROM
THE SAME SPELLED FRENCH WORD
FOR "LOVER" AND
"IS ANYONE INTERESTED?"

35% OF ALL ADVERTISERS IN
PERSONAL ADS ARE ALREADY
MARRIED.

UNTIL THE BEGINNING OF THE 20TH
CENTURY, PURE COCAINE WAS
SOLD AT HARROD'S IN
LONDON, ENGLAND.

IF YOU ORDER VIKIN-RYORI IN
JAPAN, YOU CAN PICK FOOD
FROM A SMORGASBORD.

REMBRANDT'S GRANDFATHER
WAS A BAKER.

THE LEGENDARY CLASSIC FILM
COMEDIAN HARPO MARX, ALONG
WITH HIS CHATTY BROTHERS,
BECAME FAMOUS FOR NOT SPEAKING
A SINGLE WORD ON SCREEN.
IN REAL LIFE, HE HAD NO TROUBLE
UTTERING THE SPOKEN WORD.

LONDON ENGLAND'S CLOCKWORK IS
LOCATED ON THE CLOCK TOWER OF
WESTMINSTER BRIDGE. IT IS ALSO
KNOWN AS BIG BEN AND FOR
KEEPING THE EXACT TIME.
IN 1945, HOWEVER, IT SLOWED DOWN
BY FIVE MINUTES DUE TO A FLOCK
OF STARLINGS SITTING ON THE
MINUTE HAND.

THERE ARE TRAFFIC LIGHTS ON THE CANALS IN VENICE.

THE WORD 'SCHOOL' COMES FROM THE GREEK WORD 'SKHOL', WHICH MEANS LEISURE TIME, TIME FOR SPIRITUAL EXERCISES.

IN THE AMERICAN CITY OF MONTPELIER, A CONTEST IS HELD EACH YEAR TO DETERMINE WHO HAS THE MOST WORN OUT PAIR OF SNEAKERS. THE CONTEST IS CALLED *THE ANNUAL INTERNATIONAL ROTTEN SNEAKER CONTEST.*

THE METALLIC ELEMENT GALLIUM
HAS A MOST PECULIAR PROPERTY.
IF YOU PUT A PIECE OF THE METAL
IN YOUR HAND, IT WILL MELT.
THE MELTING POINT OF THE METAL IS
29.76 DEGREES CELSIUS, (85.312°F).

AN ELK HAS FOUR STOMACHS.

ALFRED HITCHCOCK MADE IT A
GIMMICK BY HAVING A CAMEO IN HIS
OWN MOVIES FOR A FEW SECONDS.
HOWEVER, IN 25 OF HIS MOVIES YOU
CAN'T SEE HIM.

A RAT'S TEETH GROW ABOUT
6 INCHES IN A YEAR.

ADOLF HITLER WAS BORN IN
AUSTRIA BUT MOVED TO GERMANY
TO AVOID BEING CALLED FOR
MILITARY SERVICE.

THE JAPANESE NATIONAL ANTHEM IS
THE OLDEST ANTHEM IN
THE WORLD.

A CROCODILE CAN´T
STICK ITS TONGUE OUT.

**DURING AN ORDINARY DAY, YOUR
HAND WILL INDIRECTLY COME IN
CONTACT WITH 15 PENISES.**

**STEVIE WONDER MADE HIS RECORD
DEBUT WHEN HE WAS JUST
12 YEARS OLD.**

HOLLAND AND THE NETHERLANDS ARE NOT ONE IN THE SAME. SINCE THE 16TH CENTURY, THE NAME OF THE NATION HAS BEEN THE NETHERLANDS. HOLLAND CONSISTS OF TWO PROVINCES THAT TOGETHER ONLY COVER ONE SIXTH OF THE AREA OF THE NETHERLANDS.

A COW BURPS EVERY 40 SECONDS.

BEFORE THEY CHANGED THEIR NAMES, DEMI MOORE WAS CALLED DEMETRIA GUYNES, AND WALTHER MATTHAU WAS CALLED WALTER MATUSHANSKATASKY.

THE AVERAGE AGE FOR A PORSCHE
OWNER IS 49 WHILE THAT OF A
HARLEY DAVIDSON OWNER IS 52.

THE AUSTRALIAN ABORIGINALS
HAVE MORE TEETH THAN ANY OTHER
HUMAN BEING.

IN FAIRBANKS, ALASKA
A LAW FORBIDS ELK TO HAVE
SEX ON THE STREETS.

THE AVERAGE MAN WILL HAVE
ABOUT 7,200 ORGASMS
IN A LIFETIME.

THE AVERAGE SPEED OF A
MAN'S ORGASM IS 28 MPH.

WHALES HAVE NO VOCAL CORDS.

ONLY 55% OF ALL AMERICANS KNOW
THAT THE SUN IS A STAR.

JAMES DEAN'S REAL NAME WAS
JAMES BYRON, AND WHOOPI
GOLDBERG WAS BORN
CARYN JOHNSON.

THE ODDS OF DYING WHILE FALLING
OUT OF BED ARE 1 IN 2 MILLION.

ON AVERAGE, EVERY PERSON
WILL SWALLOW THREE SPIDERS
EACH YEAR.

WHEN EINSTEIN WAS NINE YEARS OLD, HE COULD NOT SPEAK PROPERLY. HIS PARENTS SUSPECTED THAT HE WAS MENTALLY RETARDED.

MOST COLLECT CALLS ARE MADE ON FATHER'S DAY.

GEORGE WASHINGTON GREW MARIJUANA IN HIS GARDEN.

IF YOU SPEND ONE HOUR IN A
PUBLIC SWIMMING POOL, YOU
WILL COME IN CONTACT WITH
ABOUT 50 OUNCES OF URINE.

MORE THAN 110 BILLION
TAMPONS HAVE BEEN
SOLD SINCE 1936.

IF YOU ARE EXTREMELY AFRAID
OF MEN, YOU MAY BE SUFFERING
FROM ANDROPHOBIA.

IN ONE YEAR, YOU WILL SWALLOW
14 BUGS IN YOUR SLEEP.

EACH YEAR YOU WILL SHAKE HANDS
WITH 11 WOMEN WHO HAVE RECENTLY
MASTURBATED WITHOUT WASHING
THEIR HANDS AFTERWARDS.

DURING YOUR LIFETIME, 22 CON-
TRACTED WORKERS (CARPENTERS,
ELECTRICIANS, ETC.) WILL HAVE
SNOOPED THROUGH THE CONTENTS
OF YOUR LAUNDRY HAMPER.

EVERY DAY, YOU INHALE ABOUT 61 CUBIC INCHES OF OTHER PEOPLES' FARTS.

A RAT CAN LIVE LONGER WITHOUT WATER THAN A CAMEL CAN.

THE MOST COMMON NAME IN THE WORLD IS MOHAMMED.

THE AVERAGE MAN EATS 110,000 POUNDS OF FOOD DURING HIS LIFETIME.

MOST PEOPLE FALL ASLEEP WITHIN 7 MINUTES.

DURING A SPACE TRIP, IT WAS DISCOVERED THAT FROGS ARE ABLE TO THROW UP. FIRST, THE FROG WILL THROW UP ITS STOMACH, SO THAT IT HANGS OUT OF ITS MOUTH. NEXT, WITH ITS FRONT LEGS, THE FROG WILL REMOVE THE STOMACH CONTENTS. WHEN FINISHED, IT SWALLOWS THE STOMACH PUTTING IT BACK IN PLACE.

THE HUMAN BODY CONTAINS ENOUGH
FAT TO MAKE SEVEN BARS OF SOAP
AND ENOUGH IRON TO MAKE ONE
SEVEN INCH NAIL.

26 ASTRONAUTS HAVE REPORTED
SEEING UFOS WHILE CIRCLING
THE EARTH.

YOUR BRAIN USES 10 TIMES
MORE OXYGEN THAN THE
REST OF YOUR BODY.

A CAUCASIAN MALE'S RIGHT TESTICLE WEIGHS TWICE AS MUCH AS THAT OF AN ASIAN MALE'S WHICH AVERAGES 0.35 OUNCES.

THE BAT IS THE ONLY MAMMAL THAT CAN FLY.

LORD NELSON WAS MISSING TWO BODY PARTS - ONE LEG AND ONE EYE.

THE "BIG KAHUNA BURGER" WAS NOT ONLY EATEN IN *PULP FICTION*. IT WAS ALSO CONSUMED IN TWO OF QUENTIN TARANTINO'S OTHER MOVIES, *FROM DUSK TILL DAWN* AND *RESERVOIR DOGS*.

SOME HENS PRODUCE GREEN EGGS.

THERE ARE NO FISH IN THE DEAD SEA.

IT WAS PASTA THAT BROUGHT FORTH
THE INVENTION OF THE DINNER
FORK. FOR HUNDREDS OF YEARS,
PEOPLE IN NAPLES ATE THEIR
MACARONI WITH THEIR FINGERS.
HOWEVER, IT WAS CONSIDERED BAD
MANNERS FOR ROYALTY TO EAT
THIS WAY WHILE WEARING GOLDEN
KNIT SILK DRESSES IN THE
ROYAL COURT. KING FERDINAND OF
SPAIN WELCOMED THE INVENTION OF
THE FORK AS IT SUPPORTED
HIS FONDNESS FOR MACARONI.

THE WAR BETWEEN ENGLAND AND FRANCE, CALLED "THE HUNDRED YEAR WAR" WENT ON BETWEEN 1337 AND 1453, WHICH MEANS THAT IT ACTUALLY LASTED FOR 116 YEARS!

VINCENT VAN GOGH AND PAUL GAUGUIN SHARED A STUDIO FOR NINE WEEKS. THE TWO ARTISTS OFTEN HAD FIGHTS WITH EACH OTHER AND, DURING A MAD MOMENT, VAN GOGH CUT OFF A PIECE OF HIS OWN LEFT EAR.

IF YOU SUFFER FROM ONOMATOPHOBIA, YOU ARE ENORMOUSLY SCARED OF HEARING CERTAIN NAMES OR WORDS.

RECYCLING IS VERY POPULAR IN THE MOVIE INDUSTRY. FOR EXAMPLE, THE SET FROM THE AXIS CHEMICAL INDUSTRY IN *BATMAN* WERE REMAINS PREVIOUSLY USED IN THE CLASSIC MOVIE *ALIEN*. ROOFTOP SCENERY AND BUILDINGS IN *THE MATRIX* WERE USED A YEAR EARLIER IN *DARK CITY*.

THE LONGEST ESCALATOR IN THE
WORLD CAN BE FOUND IN
ST. PETERSBURG, RUSSIA – 729
STEPS BRING THE TRAVELLER MORE
THAN 64.5 YARDS (193.5 FEET) UP
OR DOWN.

SOME PLANTS IN THE MISTLETOE
FAMILY EMPLOY AN UNUSUAL
METHOD FOR SPREADING THEIR
SEEDS. WHEN READY, THE PLANT
EXPLODES AND SHOOTS ITS SEEDS
OFF IN ALL DIRECTIONS AT A SPEED
OF 30 MPH.

THE ABBREVIATION "EEG" STANDS
FOR "ELECTROENCEPHALOGRAPHY"

ORIGINALLY, QUENTIN TARANTINO
WROTE MISTER PINK'S ROLE IN
RESERVOIR DOGS FOR HIMSELF.
IN THE END, STEVE BUSCEMI PLAYED
THE PART.

IN FRANCE, WALKIE TALKIE
IS CALLED TALKIE WALKIE
AND AIDS IS CALLED SIDA.

THE RED CIRCLE ON THE JAPANESE
FLAG SYMBOLIZES THE RISING SUN.

VINCENT VAN GOGH CREATED OVER
800 PAINTINGS AND 700 SKETCHES
YET ONLY SUCCEDED IN SELLING ONE
PAINTING IN HIS LIFETIME.

IN 1970, SOVIET SCIENTISTS TRIED
TO TRAIN CATS TO CONTROL ROBOTS.
THE ATTEMPT FAILED.

IN THE USA, 13 PEOPLE DIE EVERY
YEAR FROM VENDING MACHINES
FALLING ON THEM.

AN ELEPHANT'S BRAIN IS FIVE TIMES LARGER THAN A HUMAN BRAIN.

EGYPTIAN MUMMIES WERE NOT ORIGINALLY EMBALMED. THEY WERE LAID OUT ON THE HOT DESERT SAND TO DRY WITHOUT ROTTING.

WHALES CAN HAVE LICE.

PETROLEUM IS COLORLESS. RED DYE
IS ADDED SO THAT IT IS NOT
CONFUSED WITH OTHER FUELS.

THE FIRST MASSAGE DEVICE WAS
INVENTED IN 1869 AND POWERED
BY STEAM.

ACCORDING TO AN INVESTIGATION,
HALF OF ALL MEN RAISED ON A
FARM HAVE HAD SEXUAL CONTACT
WITH ANIMALS.

PEANUTS ARE NOT TRUE NUTS BUT ARE A MEMBER OF A FAMILY OF LEGUMES RELATED TO PEAS, LENTILS, CHICKPEAS AND OTHER BEANS.

THE HITCHHIKER'S GUIDE TO THE GALAXY BY DOUGLAS ADAMS WAS FIRST RELEASED AS A RADIO SERIES, THEN A BOOK.

ON A HOT DAY, UP TO TEN TONS OF WATER CAN EVAPORATE FROM THE LEAVES OF A LARGE TREE.

YOU SUFFER FROM DENDROPHOBIA IF YOU DON'T LIKE TO BE NEAR TREES OR ARE DEADLY AFRAID OF THEM.

A BABY'S CRY CAN REACH 90 DECIBELS. A NORMAL CONVERSATION MEASURES AROUND 60 DECIBELS AND A CAR HORN 110 DECIBELS.

DO YOU GET HEADACHES WHEN EATING ICE CREAM? ONE THIRD OF THE WORLD'S POPULATION SUFFERS FROM IT. IT'S CALLED "SPHENO PALATINE GANGLEONEURALGIA."

THE GREAT WHITE WHALE IN *MOBY DICK* BY HERMAN MEVILLE WAS IN FACT A SPERM WHALE.

TWO MILLION MITES LIVE IN YOUR BED.

WHEN STEVE BUSCEMI PLAYED MASS MURDERER, GARLAND GREEN, IN THE MOVIE *CON AIR*, HE ASKED THE DIRECTOR WHETHER OR NOT HE NEEDED A WIG OR ANY SPECIFIC MAKEUP TO MAKE HIM LOOK SCARIER. THE DIRECTOR TOLD HIM IT WOULD BE ENOUGH TO JUST LOOK LIKE HIMSELF.

IN 1994, 36,021 WRONGLY PARKED
CARS WERE TOWED AWAY IN
NEW YORK CITY.

TOM HANKS, WHO PLAYED THE LEAD
CHARACTER IN *FORREST GUMP* HAS
HIS EYES CLOSED IN EVERY STILL
PHOTO SHOWN IN THE MOVIE OF
FORREST'S LIFE.

A LIGHTNING BOLT IS NOT VERY WIDE
– USUALLY BETWEEN 1 TO 2 INCHES
BUT IT CAN BE UP TO 6 INCHES IN
WIDTH. ITS LENGTH IS MUCH MORE
DAZZLING – OFTEN BETWEEN 328
YARDS AND 2 MILES LONG.

PASTA MEANS DOUGH IN ITALIAN.

A MORE FITTING WORD FOR WRITER'S CRAMP IS "MIGIOGRAPHY".

THE PRODUCERS, OF THE FILM *SEVEN*, WANTED KEVIN SPACEY'S NAME AMONG THE CREDITS AT THE BEGINNING OF THE MOVIE. BUT SPACEY DIDN'T WANT THIS. HE WANTED TO SURPRISE THE AUDIENCE AND NOT GIVE AWAY THE FACT THAT HE WAS THE MURDERER. THE PRODUCERS DID AS HE WISHED AND PLACED HIS NAME FIRST AMONG THE CREDITS AT THE END OF THE MOVIE.

APPROXIMATELY 100 PEOPLE DIE EACH YEAR CHOKING ON BALLPOINT PENS.

AMERICAN DENTISTS RECOMMEND THAT YOU KEEP YOUR TOOTHBRUSH AT LEAST 6 FEET FROM A FLUSHING TOILET. THIS WILL HELP PREVENT UNINVITED AIRBOURNE PARTICLES FROM ALIGHTING ONTO YOUR TOOTHBRUSH AND ENDING UP IN YOUR MOUTH.

THE ABBREVIATION "DVD" CAN STAND FOR EITHER "DIGITAL VIDEO DISC" OR"DIGITAL VERSATILE DISC".

THE SHORTEST MOVIE REVIEW IS
LEONARD MALTIN'S REVIEW OF THE
FILM *ISN'T IT ROMANTIC?* (1948)
HIS REVIEW SIMPLY SAID, "NO".

ANOTHER MORE COMPLICATED WORD
FOR SQUINTING IS "STRABISMUS".

IN *TOY STORY 2*, A CALENDAR FROM
A BUG'S LIFE IS BRIEFLY DISPLAYED.
BOTH COMPUTER ANIMATED FILMS
WERE PRODUCED BY PIXAR.

IN GREEK MYTHOLOGY, EROS IS THE GOD OF LOVE. IN ROMAN MYTHOLOGY, HIS NAME IS AMOR.

WHEN MONTY PYTHON'S FILM *LIFE OF BRIAN* WAS RELEASED IN 1979, IT WAS FORBIDDEN IN NORWAY BUT RELEASED THERE ONE YEAR LATER.

ACCORDING TO LEGEND, AZTEC RULER MONTEZUMA DRANK 50 CUPS OF CHOCOLATE EVERY DAY FROM GOBLETS MADE OF PURE GOLD.

LOS ANGELES'S FULL NAME IS "EL PUEBLO DE NUESTRA SENORA LA REINA DE LOS ANGELES DE PORCIUNCULA".

HEAVY WATER IS ACTUALLY 10 % HEAVIER THAN ORDINARY WATER.

DANNY DEVITO GOT THE PART OF MARTINI IN THE FILM *ONE FLEW OVER THE CUCKOO'S NEST* BECAUSE HE HAD PLAYED THIS SAME ROLE ON BROADWAY A COUPLE OF YEARS EARLIER.

IN 1984, THE BELGIAN ADVENTURER
BRUNO LEUNEN BOUGHT THE
LONGEST TICKET IN THE WORLD FOR
HIS JOURNEY AROUND THE WORLD.
IT INCLUDED 80 AIRLINE COMPANIES
AND 109 INTERMEDIATE
LANDINGS. WHEN THE TICKET WAS
PRINTED OUT, IT WAS 40 FEET LONG!

THE CIGARETTE LIGHTER WAS
INVENTED BEFORE MATCHES WERE.

ALL POLAR BEARS ARE
LEFT HANDED.

WOMEN BLINK ALMOST TWICE AS
OFTEN AS MEN DO.

YOU CAN LEAD A COW UPSTAIRS
BUT NOT DOWNSTAIRS.

ONLY ONE PERSON IN TWO
BILLION WILL LIVE TO BE 116
YEARS OR OLDER.

ELEPHANTS ARE THE ONLY
ANIMALS THAT CAN'T JUMP.

YOUR SPINAL MARROW MEASURES
APPROXIMATELY 17 INCHES IN
LENGTH AND ONLY WEIGHS
ABOUT 1 OUNCE.

GENUINE PEARLS MELT WHEN
PUT INTO VINEGAR.

THE TASTEBUDS OF BUTTERFLIES
ARE ON THEIR FEET.

THE LATIN WORD FOR SEALS IS "PINNIPEDIA", WHICH MEANS FIN FOOTED.

IF A TURKEY LOOKS UP WITH ITS MOUTH OPEN WHEN IT'S RAINING, IT COULD DROWN.

THE WORLD'S LONGEST UNIT OF TIME IS THE HINDUS KALPA. IT IS EQUIVALENT TO 4,000,000,032 YEARS, THE TIME IT TAKES TO FLATTEN THE HIMALAYA MOUNTAIN RANGE BY SCRAPING AWAY AT IT WITH A SILK THREAD.

IN EVERY EPISODE OF *SEINFELD*,
YOU CAN SEE SOMETHING WITH
SUPERMAN ON IT.

AT MORE THEN 10,000-YEARS-OLD,
A CONIFEROUS TREE, ON THE ISLAND
OF TASMANIA, IS THE OLDEST
KNOWN LIVING ORGANISM. IT HAS
LIVED THROUGH THE CULTURAL
DEVELOPMENT OF MANKIND AND
MAGESTICALLY COVERS AN AREA AS
LARGE AS A CITY BLOCK.

IN THE FILM *GOLD RUSH*, A
STARVING CHARLIE CHAPLIN EATS
HIS OWN SHOES. THESE SHOES WERE
ACTUALLY MADE FROM LICORICE.

ONE OF CHINA'S GOALS IS THAT
EVERY CITIZEN SHOULD BE ABLE TO
EAT 200 EGGS YEARLY.
IT IS ESTIMATED THAT IN ORDER TO
FEED 1.3 BILLION PEOPLE 200 EGGS
ANNUALLY, THAT WOULD REQUIRE 1.3
BILLION HENS WHO WOULD EAT MORE
GRAIN THAN AUSTRALIA PRODUCES
YEARLY.

CERTAIN TROPICAL FISH ARE ABLE
TO CLIMB TREES – SOME UP TO A
HEIGHT OF 32 FEET. MANY OF THEM
ARE SO APT AT BREATHING THEY
WOULD DROWN IF FORCED TO STAY
UNDERWATER FOR TOO LONG.

IN THE STATE OF ARIZONA, IT IS
FORBIDDEN TO LICK A BUFO
ALVARIUS. THIS TOAD SECRETES A
POTENT SUBSTANCE THAT SCARES
PREDATORS AWAY. IT ALSO WORKS
AS A HALLUCINOGENIC DRUG AND
SOME ABUSERS LICK IT OFF THE
TOADS WHILE OTHERS SCRAPE IT
OFF THE SKIN AND SMOKE IT.

BOTTLED WATER COSTS ALMOST 1,000 TIMES MORE THAN TAP WATER.

ACCORDING TO MATHEMATICAL EXPERTS, A DECK OF CARDS MUST BE SHUFFLED AT LEAST SEVEN TIMES TO AVOID HAVING THEM END UP AS THEY WERE FROM THE START OF THE SHUFFLE.

WHAT DO AMERICANS GET STUCK IN THEIR THROATS MORE THAN ANY OTHER OBJECT? TOOTH PICKS.

IN QUENTIN TARANTINO'S FILM *PULP FICTION*, ALL THE WATCHES SHOW TWENTY MINUTES PAST FOUR O'CLOCK. IT IS SUGGESTED THAT THIS IS A REFERENCE TO THE INVENTOR OF LSD, ALBERT HOFFMAN, WHO TOOK HIS FIRST LSD TRIP ON APRIL 19, 1943 AT 4:20 PM.

ON AVERAGE, A PERSON HAS ABOUT 100,000 HAIRS GROWING ON TOP OF THEIR HEAD AND THEY LOSE BETWEEN 50 TO 100 OF THEM EVERYDAY. A BLOND SPROUTS ABOUT 140,000, A REDHEAD HAS AROUND 90,000 AND A BROWN HAIRED INDIVIDUAL'S HEAD BARES SOMETHING IN BETWEEN.

THERE IS AN INTERNATIONAL SOCIETY WHOSE SOLE PURPOSE IS TO INFORM THE WORLD THAT ALL SCIENTIFIC FACTS ARE FALSE. AMONG OTHER THINGS, ITS MEMBERS MAINTAIN THAT THE EARTH IS FLAT AND THAT THE DISTANCE BETWEEN THE EARTH AND SUN IS 3,221 MILES - NOT 92 MILLION MILES.

BRITAIN'S QUEEN ELIZABETH THE FIRST WAS EXTREMELY GENEROUS WITH HER MAKEUP. WHEN SHE PASSED AWAY, SHE WAS MADE UP WITH A LAYER OF LIPSTICK 1/3 OF AN INCH IN THICKNESS.

WHENEVER YOU SEE A DOG PAWING AT THE GROUND AFTER FINISHING ITS BUSINESS, DO YOU THINK IT'S NEATLY COVERING UP ITS POO? WELL, IT'S NOT. THEY ARE LEAVING TRACES OF THEIR UNIQUE SCENT BEHIND, WHICH IS RELEASED FROM ODOUR GLANDS ON THE BOTTOM OF THEIR PAWS.

WHEN FLYING DOMESTICALLY WITHIN THE USA, STATISTICALLY YOU MUST FLY EVERYDAY FOR 19,000 YEARS BEFORE HAVING AN ACCIDENT.

IT'S MORE STRAINING FOR THE VOCAL CHORDS TO WHISPER THAN TO SPEAK IN A NORMAL VOICE.

THE TRANS-SIBERIAN RAILWAY IS A 5,778-MILE LONG ROUTE THROUGH RUSSIA, FROM MOSCOW TO VLADI-VOSTOK. EARLIER TRAVELLERS HAD TO TAKE THIS JOURNEY BY BOAT ACROSS LAKE BAIKAL. A ONE-WAY TRIP ON THE TRANS-SIBERIAN RAILWAY TAKES 7 LONG DAYS.

IN 1964, THE FIRST LASER WAS REPRODUCED ON FILM IN *GOLDFINGER*.

IN 1969, APOLLO 1 TOOK THE FIRST MAN TO THE MOON.
ITS STEERING SYSTEM WAS LESS ADVANCED THAN COMPUTERS AND CALCULATORS ARE TODAY.

DAVID PROWSE DID NOT KNOW THAT FELLOW ACTOR JAMES EARL JONES WAS GIVING HIS VOICE TO PROWSE'S CHARACTER, DARTH VADER, IN THE MOVIE *STAR WARS*.
HE FIRST NOTICED WHILE WATCHING THE PREMIERE.

SWEDEN'S GLOBEN ARENA, BUILT IN STOCKHOLM BETWEEN 1986 AND 1988, IS THE LARGEST SPHERICAL BUILDING IN THE WORLD.

A RECENTLY DISCOVERED SPECIES OF ANTS HAS BEEN NAMED AFTER HARRISON FORD. THE SPECIES IS CALLED PEIDOLE HARRISONFORDI.

IF YOU DON'T COVER YOUR MOUTH WHILE SNEEZING, 20,000 SMALL DROPLETS OF SALIVA CAN FORCEFULLY PROJECT FROM YOUR MOUTH UP TO 13-FEET AWAY.

YOU WILL NEVER FIND SEEDS IN
CLEMENTINES BUT YOU WILL FIND
THEM IN MANDARINES,
THE ORIGINAL FRUIT. THE SEED-FREE
VARIETY WAS NAMED AFTER ITS CRE-
ATOR, THE FRENCH PRIEST CLEMENT,
WHO DEVELOPED IT AROUND 1900.

THE THIGHBONE AND SHINBONE
CAN BE EXPOSED TO A VERTICAL
PRESSURE UP TO 2,200 POUNDS,
WITHOUT BREAKING
- THE WEIGHT OF AN AVERAGE CAR.

DURING AN AVERAGE LIFETIME OF 70 YEARS YOU WILL BREATH 600 MILLION TIMES, FEEL 125 MILLION HEART BEATS, AND YOUR EYES WILL BLINK 350 MILLION TIMES.

THE DAILY PRODUCTION OF GASES IN YOUR LARGE INTESTINE MEASURES 2 TO 2.5 GALLONS. YOU WILL EMIT ABOUT 0.2 GALLONS OF THIS WHILE YOUR INTESTINAL WALL ABSORBS THE REST.

THE GUINNESS BOOK OF RECORDS CLAIMS THAT "MY NAME IS BOND, JAMES BOND" IS THE MOST FAMOUS MOVIE LINE IN THE WORLD.

THE GERMANS UNMASKED SEVERAL AMERICAN SPIES DURING THE SECOND WORLD WAR BY STUDYING HOW THEY ATE. THE AMERICANS CUT THEIR STEAKS IN SMALLER PIECES BEFORE THEY ATE THEM.

THE LARGEST KIDNEY STONE IN
THE HISTORY OF MEDICINE
WEIGHED 14 POUNDS.

THE SMALLEST BIRD IN THE WORLD
IS THE 2.3-INCH HUMMINGBIRD.
IT COUNTERACTS THE FORCES OF
GRAVITY BY FLAPPING ITS WINGS
OVER 200 TIMES PER SECOND.

BETWEEN THE YEARS OF 1788 AND
1868, GREAT BRITAIN DEPORTED
155,000 PRISONERS TO THEIR
COLONY AUSTRALIA.

IF THE EARTH WAS ABSOLUTELY SMOOTH AND FLAT, IT WOULD BE COVERED WITH A LAYER OF WATER 500-FEET DEEP.

IN THE POPULAR BOND FILM *FROM RUSSIA WITH LOVE*, AUTHOR IAN FLEMMING MADE A CAMEO APPEARANCE IN ONE OF THE SCENES AS A MAN TAKING A LEISURELY WALK.

RUBBER BANDS LAST LONGER IF KEPT COLD.

THE FIRST DEPORTATION TO SIBERIA IN RUSSIA WAS NOT A HUMAN BUT A SYMBOL – THE CITY BELL OF UGLICH. IN 1591, THE SON OF THE TSAR WAS MURDERED AND ANGRY CITIZENS RANG THE QUARTER TON BELL IN PROTEST. AS PUNISHMENT AND A DEMONSTRATION OF POWER, THESE AGITATORS WERE BEATEN AND THEIR TONGUES WERE CUT OFF. THE BELL WAS ALSO HAMMERED AND ITS CLAPPER WAS PULLED AWAY FROM ITS HOLD. AS A FINAL DISPLAY, THE BELL WAS DEPORTED TO SIBERIA TO BE SILENCED FOREVER.

IDLING BOAT ENGINES HAVE ACOUSTICAL CHARACTERISTICS REMINISCENT OF GREY WHALES SINGING. IN MEXICO, FISHERMAN HAVE PROBLEMS WITH WHALES RUBBING THEIR BACKS AGAINST THEIR FISHING VESSELS.

DON'T TRY THIS – IF YOU TAKE A VERY SHARP PENCIL, DIP THE VERY TIP IN NICOTINE AND PUSH THIS THROUGH YOUR SKIN, YOU WILL DIE IMMEDIATELY.

JUST BEFORE YOU FREEZE TO DEATH, YOUR BODY'S SENSE OF TEMPERATURE BREAKS DOWN AND MAKES A PERSON FEEL LIKE HE OR SHE IS ON FIRE. THIS IS WHY SOME PEOPLE, FOUND DEAD IN THE WINTERTIME, ARE UNDRESSED.

SOME OCTOPUSES LIVE IN SUCH DEEP WATER, THAT IT IS COMPLETELY DARK ALL THE TIME. HERE IT IS USELESS FOR THEM TO SQUIRT BLACK INK AT THEIR ENEMIES TO CONFUSE THEM.
INSTEAD, THE OCTOPUSES EMIT A CLOUD OF LUMINOUS GERMS THAT BLIND THEIR PREDATORS.

**MARILYN MONROE HAD SIX
TOES ON HER LEFT FOOT.**

**THE WHITE HALF-MOON SHAPE FOUND
AT THE BASE OF A FINGER NAIL IS A
SMALL, AIR-FILLED POCKET.**

**IF YOU TOOK ALL THE WHEAT THAT
IS CONSUMED AROUND THE WORLD
DURING A YEAR AND BAKED A LOAF
OF BREAD FROM IT, THAT LOAF
WOULD BE ABOUT 13-FEET WIDE AND
6.5-FEET HIGH AND LONG ENOUGH TO
GO AROUND THE EARTH ONCE.**

ONCE UPON A TIME, DISNEY'S CARTOON CHARACTER, DONALD DUCK, WAS BANNED IN FINLAND BECAUSE HE DIDN'T WEAR PANTS.

LEGO WAS INVENTED IN 1949. THE NAME COMES FROM THE DANISH WORDS "LEG", MEANING PLAY AND "GODT" MEANING GOOD.

THE STATE OF NEW JERSEY, USA PROVIDES TWO-THIRDS OF THE WORLD'S TOTAL PRODUCTION OF EGGPLANT.

THE PHILOSOPHER, RENÉ DESCARTES, WHO CONSIDERED HIMSELF TO BE THE INVENTOR OF THE FIRST PHILOSOPHICAL PRINCIPLE – COGITO ERGO SUM (I THINK, THEREFORE, I AM), - DIED WHILE VISITING QUEEN KRISTINA IN 1649. THE CASTLE WAS VERY COLD AND DESCARTES SUFFERED FROM PNEUMONIA, WHICH KILLED HIM.

THERE ARE MORE CHICKENS THAN HUMANS ON OUR PLANET.

THE SPANISH FLY IS THE WORLD'S MOST FAMOUS BUG. SOME BELIEVE IT HAS APHRODISIAC PROPERTIES. ONE THING IS FOR CERTAIN: DRIED AND POWDERED, SPANISH FLIES MAKE A POTENT POISON AND MANY HAVE DIED FROM IT. THE LAST KNOWN CASE WAS IN THE 1960'S.

AL CAPONE'S BUSINESS CARD SAID THAT HE WAS A USED FURNITURE SALESMAN.

A GOLDFISH HAS A MEMORY THAT LASTS ONLY THREE SECONDS.

MORE SHOPLIFTERS ARE CAUGHT ON A WEDNESDAY THAN ON ANY OTHER DAY OF THE WEEK.

WE ARE BORN WITHOUT KNEECAPS. THEY DEVELOP BY THE AGE OF SIX.

WILLIAM SHAKESPEARE "INVENTED" MORE THAN 1,700 WORDS.

THE WORLD FAMOUS OPERA HOUSE IN SYDNEY, AUSTRALIA WAS DESIGNED BY THE DANISH ARCHITECT JÖRN UTZON. IT´S COVERED WITH OVER ONE MILLION WHITE CERAMIC TILES, MANUFACTURED BY THE SWEDISH COMPANY HÖGANÄS.

DO YOU WANT TO BUY A CAMEL? THE LARGEST EXPORTER OF CAMELS IN THE WESTERN WORLD IS NORWAY.

YOUR EYES REMAIN THE SAME IN
SIZE FROM THE DAY YOU ARE BORN
TO THE DAY YOU DIE. YOUR NOSE
AND EARS, HOWEVER, NEVER STOP
GROWING.

THE TAME CAT CAME TO
SCANDINAVIA ABOUT 1,500 YEARS
AGO. BEFORE THAT ONE OFTEN HAD
– A TAME SNAKE!

EVERY YEAR, MORE PEOPLE
GET KILLED BY DONKEYS THAN
BY PLANE CRASHES.

YOU NEED 150,000 SAFFRON
CROCUSES TO GET TWO POUNDS
OF SAFFRON.

THE SPERM WHALE HAS THE LARGEST
BRAIN OF ALL ANIMALS IN THE
WORLD. IT WEIGHS 20 POUNDS.

FROGS NEVER DRINK WATER.
THEY GET ALL THE FLUID THEY
NEED BY LIVING IN A WET
AND MOIST ENVIRONMENT.

THE LARGEST CONCENTRATION OF ANIMALS EVER OBSERVED WAS A HUGE SWARM OF GRASSHOPPERS IN 1879. THE SWARM WAS THE SIZE OF GERMANY AND CONTAINED MORE THAN 12,500 BILLION INSECTS THAT TOGETHER WEIGHED ABOUT 55,000 BILLION POUNDS.

IN RELATION TO THEIR SIZE, BUGS THAT BELONG TO THE SPECIES SCARABEIDAE ARE THE STRONGEST ANIMALS IN THE WORLD. WHEN TESTS WERE DONE ON THE QUITE RARE ORYCTES NASICORNIS, ALSO KNOWN AS "RHINOCEROS BEETLE", IT WAS FOUND THAT IT COULD CARRY 850 TIMES ITS OWN WEIGHT ON ITS BACK.

A STRANGE FASHION COLOR WAS CREATED BY THE SOVEREIGN QUEEN ISABELLA, THE DAUGHTER OF FILIP II OF SPAIN. IN 1601, SHE SWORE NOT TO CHANGE HER UNDERWEAR UNTIL THE CITY OF OOSTENDE WAS TAKEN. UNFORTUNATELY, THE OCCUPATION LASTED FOR THREE YEARS SO ISABELLA'S UNDERWEAR GOT THE BEIGE COLOUR THAT TODAY IS KNOWN AS ISABELLA COLORED.

DENTAL ENAMEL IS THE STRONGEST MATERIAL YOUR BODY PRODUCES.

WHEN CHARLIE CHAPLIN BECAME FAMOUS FOR HIS MOVIES, A LOT OF PEOPLE STARTED TO DRESS AND ACT LIKE HIM. EVEN CHARLIE CHAPLIN LOOK-A-LIKE CONTESTS WERE HELD. CHARLIE PARTICIPATED IN ONE HIMSELF – AND WON THIRD PLACE.

A STARFISH HAS VERY BAD TABLE MANNERS. IT TURNS ITS STOMACH INSIDE OUT, BY FORCING IT OUT THROUGH ITS MOUTH AND OVER ITS PREY.

THE "BLACK BOX" EVERYONE IS LOOKING FOR AFTER A PLANE CRASH IS NOT BLACK – IT'S ORANGE, MAKING IT EASIER TO FIND. BESIDES, THERE'S NOT ONLY ONE BOX, BUT TWO. ONE IS USED FOR RECORDING ALL CONVERSATIONS AND SOUNDS IN THE COCKPIT AND THE OTHER TO SAVE ALL DATA FROM THE FLIGHT.

WHEN YOU TAKE A NAP FOR AN HOUR YOU BURN AS MUCH ENERGY AS IT TAKES TO BOIL WATER FOR SEVEN CUPS OF TEA.

THE SHORTEST WAR IN WORLD
HISTORY WAS FOUGHT BETWEEN
GREAT BRITAIN AND ZANZIBAR,
THE 27TH OF AUGUST, 1896.
IT LASTED ONLY 38 MINUTES.

IF YOUR HEART MUSCLE WAS
REQUIRED TO WORK FILLING BEER
BOTTLES IN A BREWERY, IT WOULD
BE ABLE TO FILL 1,600 CRATES OF
BEER DAILY WITH 30 BOTTLES EACH.
AND IT WOULD WORK, WITHOUT
REQUIRING ANY REPAIRS, FOR 70
YEARS.

IF YOU MULTIPLY THE NUMBER OF
INHABITANTS IN THE USA BY 2,
YOU'LL GET THE NUMBER OF CREDIT
CARDS USED IN THAT COUNTRY.

ADOLF HITLER HAD
ONLY ONE TESTICLE.

A FIVE-MONTH-OLD FETUS HAS
MORE HAIR ON ITS BACK THAN
AN ADULT GORILLA.

NOT SO LONG AGO, WHEN A PRISONER ESCAPED FROM THE ALAMOS PRISON IN MEXICO, THE RESPONSIBLE GUARD WAS SENTENCED TO SERVING THE REMAINING TIME ON THE PRISONER'S SENTENCE.

AIR FORCE PILOTS HAVE MORE DAUGHTERS (DETERMINED BY THE X-CHROMOSOME) THAN SONS (DETERMINED BY THE Y-CHROMOSOME) BECAUSE THE X-CHROMOSOME TOLERATES THE MORE STRESSFUL EFFECTS OF GRAVITY BETTER THAN THE Y-CHROMOSOME DOES.

ON AVERAGE, A HUMAN BEING HAS EIGHTEEN BLEMISHES ON HIS OR HER BODY.

A VULTURE'S STOMACH IS SO ACIDIC THAT IT CAN DISSOLVE A NAIL AFTER JUST A COUPLE OF HOURS.

FOR EACH HUMAN BEING ON EARTH, THERE ARE MORE THAN HALF A MILLION INSECTS.

ONE SINGLE TREE CAN BE HOME TO 20 MILLION LICE.

SPERM ARE CREATED IN THE MALE TESTICLES. THE TESTICLES ARE CONSTRUCTED SO THEY BUILD PIPE-FORMED STRUCTURES. IN EVERY TESTICLE THESE PIPES ARE MORE THAN 400 YARDS LONG.

A SINGLE THREAD IN A SPIDER'S WEB IS AS STRONG AS A STEEL CABLE OF THE SAME SIZE.

THE DIVISION OF BLOOD GROUPS VARIES BETWEEN DIFFERENT PEOPLE IN DIFFERENT COUNTRIES. THE ONLY GROUP OF PEOPLE WHO HAVE THE SAME BLOOD GROUP ARE AMERICAN NATIVES – O.

IN INDIA, WHERE HINDUISM IS THE MAJOR RELIGION, THEY WORSHIP OVER 300 MILLION GODS. ALMOST EVERY LITTLE VILLAGE HAS ITS OWN LOCAL GOD.

EVERY SINGLE SECOND, YOUR MARROW PRODUCES ABOUT 3 MILLION RED BLOOD CORPUSCLES. DURING THAT TIME, THE SAME AMOUNT DIE. THE DAILY PRODUCTION IS MORE THAN 200 BILLION CORPSUCLES.

ON AVERAGE, THERE ARE 94 GIRLS BORN FOR EVERY 100 BOYS, BUT AMONG QUADRUPLETS, 156 GIRLS ARE BORN FOR EVERY 100 BOYS.

IT HAS BEEN PROVEN THAT TALLER PEOPLE SCORE BETTER ON INTELLIGENCE TESTS.

ABOUT 1,000 DOWN FEATHERS CAN BE PRESSED INTO A THIMBLE. ONCE REMOVED, THEY WILL SOON REGAIN THEIR ORIGINAL VOLUME.

THE FIRST NOSE TRANSPLANTS WERE
PERFORMED IN INDIA AS EARLY AS
750 B.C. THE NOSES WERE TAKEN
FROM UNFAITHFUL WIVES.

THE ACIDITY IN THE HUMAN
STOMACH IS SO STRONG THAT
IT HAS TO BE DILUTED ABOUT 400
TIMES TO REACH THE SAME GRADE
OF SOURNESS AS COCA-COLA.

RADIUM-224 IS THE MOST
POISONOUS ELEMENT IN THE WORLD.
THIS NATURALLY OCCURRING
ISOTOPE IS 17,000 TIMES MORE
POISONOUS THAN PLUTONIUM-239.

WHEN IAN FLEMING WROTE HIS FIRST BOOK *CASINO ROYALE*, HE GOT THE NAME JAMES BOND FROM A WRITER OF A BOOK ABOUT CARIBBEAN BIRDS.

MEL BLANC, THE MAN WHO GAVE VOICE TO *BUGS BUNNY*, WAS ALLERGIC TO CARROTS.

BULLETPROOF VESTS, FIRE LADDERS, WINDSHIELD WIPERS AND LASER PRINTERS WERE ALL INVENTED BY WOMEN.

THE THREE WISE MEN WERE NAMED
CASPAR, MELCHIOR AND BALTHAZAR.

THIEVES OFTEN LISTEN AT DOORS
AND IN SOME CASES THIS HAS
GOTTEN THEM CONVICTED. THE
POLICE ARE NOT ONLY INTERESTED IN
FINGERPRINTS BUT EAR PRINTS AS
WELL, WHICH ARE UNIQUE FOR EVERY
HUMAN BEING.

IN INDIA, MORE THAN 140 MAIN
LANGUAGES ARE SPOKEN WITH
845 ACCENTS.

NEW SPECIES CAN BE FOUND IN
THE STRANGEST PLACES. A NEW ANT
SPECIE WAS FOUND IN A FLOWER POT
ON THE SIXTEENTH FLOOR OF
A GERMAN OFFICE BUILDING.

51,000 PEOPLE CAN FIT ONTO A
FOOTBALL FIELD IF THEY STAND
REALLY CLOSE TOGETHER.

IF YOU ARE AFRAID OF
ANIMALS IN GENERAL, YOU
SUFFER FROM ZOOPHOBIA.

THE CAPE OF GOOD HOPE IS NOT THE MOST SOUTHERN PART OF AFRICA. IT IS CAP AGULHA, WHICH IS LOCATED ABOUT 90 MILES SOUTH-EAST OF THE CAPE OF GOOD HOPE.

ON AVERAGE EVERY YEAR, YOU WILL CONSUME 12 PUBIC HAIRS WHILE EATING IN RESTAURANTS.

THE NATIONAL ANTHEM OF THE EUROPEAN UNION (EU) IS *AN DER FREUDE FROM THE NINTH SYMPHONY* BY LUDVIG VON BEETHOVEN.

.

JOHN WILKES BOOTH, THE MAN WHO
SHOT ABRAHAM LINCOLN, THE 16TH
PRESIDENT OF THE USA,
WAS AN ACTOR.

ONE OF THE ELEMENTS IN
DYNAMITE IS PEANUTS.

THE FIVE DIFFERENT COLORED RINGS,
ON THE OLYMPIC FLAG, SYMBOLIZE
THE UNION OF THE FIVE CONTINENTS
AND THAT THE OLYMIC GAMES SHALL
BE A MEETING PLACE FOR ATHLETES
FROM AROUND THE WORLD. AT
LEAST ONE COLOR OF EACH RING CAN
BE FOUND ON EVERY WORLD FLAG.

SEAN CONNERY, THE FIRST JAMES BOND, WON THE MR. UNIVERSE CONTEST BEFORE HE BECAME AN ACTOR.

A CAT HAS THIRTY-TWO MUSCLES IN EACH EAR.

DID YOU THINK THAT THE MONKEYS IN THE ZOO WERE PICKING FLEAS OFF EACH OTHER?
WRONG; THEY ARE IN FACT GROOMING FOR SALTY SKIN DANDER.

WHEN YOU'RE USING THE
COMPUTER KEYBOARD,
YOUR LEFT HAND DOES
56% OF THE TYPING.

THE ACTUAL MEANING OF THE WORD
TURKEY IS "COCK FROM CALICUT".

THE ZIPPER WOULD NOT HAVE
BECOME THE SUCCESS IT DID IF IT
HADN'T BEEN FOR WORLD WAR ONE.
ORIGINALLY, IT WASN'T USED ON
CLOTHING BUT ON MONEY BELTS
THAT THE AMERCIAN SOLDERS
BROUGHT TO EUROPE.

**MANY HAMSTERS BLINK
ONLY ONE EYE AT A TIME.**

**THE PACEMAKER WAS INVENTED IN
THE 1950'S BY SWEDEN'S RUNE
ELMQVIST AT THE PACESETTER
COMPANY.**

**THE CHANCE OF SURVIVING A PLANE
CRASH IS BETTER IN SEATS FOUND IN
THE BACK OF A PLANE WHERE YOU
HAVE THE BEST PROTECTION DURING
TAKE OFFS AND LANDINGS. THIS IS
WHEN THE RISK OF AN ACCIDENT IS
AT ITS GREATEST.**

IF BARBIE HAD BEEN A REAL HUMAN BEING, HER MEASUREMENTS WOULD HAVE BEEN 97-58-97.

IT'S OFTEN WARMER IN CITIES THAN IN THE COUNTRYSIDE. THE REASON BEING ASPHALT ABSORBS MORE ENERGY FROM THE SUN THAN GRASS, TREES AND PLANTS DO.

THE LONGEST BORDER BETWEEN TWO STATES IN EUROPE IS THE BORDER BETWEEN SWEDEN AND NORWAY. IT'S 1,000 MILES LONG.

JOHN RHYS-DAVIES, WHO PLAYED GIMLI THE DWARF IN THE THREE *LORD OF THE RINGS* MOVIES HAD A TOUGH TIME DURING FILMING. HIS ARMAMENT WEIGHED 66 POUNDS AND HE WAS ALSO ALLERGIC TO THE PROSTHETIC GLUE.

AT FIRST, CINDERELLA'S SHOES WERE MADE OF LEATHER BUT WHEN THE FOLKTALE WAS WRITTEN DOWN IN THE 16TH CENTURY, THE FRENCH WORDS "VAIR" AND "VERRE" WERE MIXED UP. THE FIRST MEANS SKIN AND THE LATTER MEANS GLASS.

ON AVERAGE, A HURRICANE PRODUCES MORE ENERGY THAN ALL OF THE WORLD'S POWER PLANTS PUT TOGETHER.

IN 1899, THE EIFFEL TOWER WAS BUILT BY GUSTAVE EIFFEL FOR THE PARIS EXHIBITION AND WAS SUPPOSE TO BE DEMOLISHED AFTERWARDS.

ONE DAY – THE TIME IT TAKES OUR PLANET TO ROTATE AROUND ITS AXIS – WOULD TAKE ONLY 9 HOURS AND 55 MINUTES ON THE PLANET JUPITER.

THE AFRICAN OSTRICH IS NOT ONLY
THE LARGEST BIRD IN THE WORLD-
IT ALSO LAYS THE LARGEST EGGS.
ON AVERAGE, ONE EGG WEIGHS 2 TO
4 POUNDS.
THAT'S EQUIVALENT TO THE WEIGHT
OF 45 NORMAL-SIZED EGGS.

IF YOU NEVER CUT YOUR HAIR AND
LIVED TO BE 77-YEARS OLD, YOUR
HAIR COULD GROW 690 MILES LONG.

A NEWBORN KANGAROO WEIGHS
APPROXIMATELY ONE GRAM
(0.035 OUNCES).

HURRICANES ARE ALWAYS GIVEN
NAMES IN ORDER TO MAKE THEM
EASIER TO TRACK. THEIR NAMES
ALWAYS START WITH AN "A" AT THE
BEGINNING OF EACH YEAR.
IN 1979, THE WOMEN'S MOVEMENT
PRESSURED METEOROLOGISTS TO
USE BOTH MALE AND FEMALE NAMES
INSTEAD OF JUST FEMALE NAMES.
TODAY, BOY NAMES ARE USED ON
EVEN NUMBERED YEARS AND GIRL
NAMES ON UNEVEN ONES.

VOLVO MEANS
"I AM ROLLING"
IN LATIN.

PRODUCTION SUFFERED A SEVERE CATASTROPHE ONE-DAY WHILE FILMING *DIAMONDS ARE FOREVER.* UNEXPECTEDLY, ALL OF THE TROPICAL FISH IN THE AQUARIUM DIED. THE SOLUTION WAS TO FREEZE THE FISH AND SUSPEND THEM IN THE TANK FROM INVISIBLE THREAD THAT COULD BE MOVED; MAKING THEM APPEAR ALIVE.

IT IS IMPOSSIBLE TO SNEEZE WITH YOUR EYES OPEN.

AN ICE CREAM HEADACHE OCCURS WHEN THE COLDNESS OF THE ICE CREAM COMES IN CONTACT WITH A SPIDER-SHAPED WEB OF NERVES ON THE ROOF OF THE MOUTH. WHEN THE TEMPERATURE OF THESE NERVES COOLS DOWN, THE BRAIN BELIEVES THAT IT'S ABOUT TO FREEZE AND UNNECESSARILY SENDS WARM BLOOD TO THE AREA. INSTEAD OF WARMING THE AREA, IT CAUSES A HEADACHE.

THE FACE OF THE ALIEN E.T IN THE FILM WITH THE SAME NAME, WAS MODELLED AFTER THE POET CARL SANDBURG, THE PHYSICIST ALBERT EINSTEIN AND A PUG.

THE PLANE BUDDY HOLLY CRASHED
IN WAS NAMED "AMERICAN PIE".
DON MCLEAN ADOPTED THIS NAME
FOR A SONG HE RELEASED A COUPLE
OF YEARS LATER.

THE SLOTH MOVES SO SLOW ALGAE
CAN GROW UNHINDERRED ON IT.
THAT IS WHY ITS SKIN IS
SOMETIMES GREEN.

IT'S NOT ONLY THE TIGER'S FUR
THAT IS STRIPED.
THE SKIN IS STRIPED AS WELL.

THE EXPRESSION "CHECKMATE"
COMES FROM THE ARABIC EXPRES-
SION "SHAH MAT", WHICH MEANS
"THE KING IS DEAD".

DO YOU THINK "BIG BEN" IS A
TOWER OR A CLOCK FACE? WELL,
BOTH ARE WRONG GUESSES. THIS
WELL-KNOWN NAME ACTUALLY
BELONGS TO THE BELL THAT SOUNDS
EVERY HOUR BEHIND THE FAMOUS
CLOCK FACE IN LONDON, ENGLAND.

WHEN THE NORTH AMERICAN
POSSUM IS THREATENED, IT NOT
ONLY PLAYS DEAD TO ESCAPE THE
DANGER, IT ALSO FAINTS FROM
FEAR!

SESAME STREET PUPPET CHARAC-
TERS BERT AND ERNIE'S NAMESAKES
ARE THE POLICEMAN, BERT AND THE
TAXI DRIVER, ERNIE, FROM THE
CLASSIC FILM *IT'S A WONDERFUL
LIFE* STARRING JIMMY STEWART.

DID YOU KNOW THAT CAMELS HAVE
THREE EYELASHES TO PROTECT THEIR
EYES FROM THE BLOWING SAND?

A DONKEY'S EYES ARE POSITIONED
SO THAT IT CAN SEE ALL OF ITS
HOOVES AT THE SAME TIME.

WHEN YOU ARE BORN, YOU HAVE 300 BONES IN YOUR BODY BUT WHEN YOU DIE, YOU ONLY HAVE 206.

THE ONLY KNOWN MONTH TO NOT HAVE A FULL MOON IS FEBRUARY 1865.

ACCORDING TO THE AUTHOR IAN FLEMING, JAMES BOND'S FATHER WAS FROM SCOTLAND AND HIS MOTHER FROM FRANCE.

AN OSTRICH'S EYE IS LARGER THAN ITS BRAIN.

THE TOASTER WAS INTRODUCED BY GENERAL ELECTRIC IN THE USA IN 1909.

THE LEANING TOWER OF PISA, ONE OF ITALY'S GREATEST TOURIST ATTRACTIONS, LEANS IN A SOUTHERLY DIRECTION.

THE LATIN INSCRIPTION I.N.R.I. STANDS FOR "IESUS NAZARENUS, REX IUDAEORUM" WHICH MEANS "JESUS OF NAZARETH, KING OF THE JEWS".

DURING THE SECOND WORLD WAR, QUEEN ELIZABETH II STUDIED TO BECOME A CAR MECHANIC.

IN PARAGUAY, DUELLING IS ONLY LEGAL IF BOTH FIGHTERS ARE REGISTERED BLOOD DONORS.

A DIAMOND'S WEIGHT IS MEASURED IN CARATS. ORIGINALLY, ONE CARAT EQUALLED THE WEIGHT OF ONE SEED FROM A LOAF OF ST. JOHN'S BREAD. IT WAS CHANGED IN 1931 THAT THE EXACT WEIGHT WAS TO BE 0.2 GRAMS.

SOUTH AFRICA HAS ELEVEN MAIN LANGUAGES, WHICH EXPLAINS WHY YOU CAN SOMETIMES FIND REALLY LONG ROAD SIGNS. EVERYONE MUST BE ABLE TO READ THEM!

THE EARTH WEIGHS ABOUT 5,924,000,000,000,000,000,000 METRIC TONS.

CONTRARY TO POPULAR BELIEF, THOMAS ALVA EDISON DID NOT INVENT THE LIGHTBULB. MANY HAD DONE THIS BEFORE HIM. WHAT HE DID, HOWEVER, WAS MODIFY THE LIGHTBULB AND PATENT IT.

AN ANGRY MALE HUMMINGBIRD HAS A PULSE OF UP TO 1,000 BEATS PER MINUTE WHILE, AT THE SAME TIME, DRAWING ABOUT 500 BREATHS.

IN 1820, SCIENTISTS BELIEVED THE UNIVERSE TO BE 6,000 YEARS OLD. TODAY, EXPERTS DATE IT BETWEEN 15 TO 20 BILLION YEARS OLD.

A BLACK HOLE IS A COLLAPSED STAR THAT HAS TURNED INTO A TINY BLACK GLOBE. THE HOLE IS BLACK BECAUSE OF ITS ENORMOUS FORCE OF GRAVITY THAT WON'T LET ANY LIGHT OUT.

SOME MALE SPIDERS HAVE VERY INTERESTING SURVIVAL TECHNIQUES. TO AVOID BEING EATEN BY A FEMALE, THE MALE SPIDER WILL ENTWINE HER IN A COBWEB BEFORE MATING.

IN LONDON, ENGLAND'S FIRE OF 1666, HALF OF THE CITY BURNED DOWN, BUT MIRACULOUSLY ONLY SIX PEOPLE WERE INJURED.

THE OSCAR STATUES ARE NORMALLY MADE OF TIN AND COPPER, BUT DURING THE SECOND WORLD WAR, THEY WERE MADE OF PLASTER, COVERED IN GOLD. ALL METAL WAS NEEDED FOR THE WAR EFFORT.

MOSQUITOES LIVE ON NECTAR NOT BLOOD. BLOOD IS REQUIRED FOR PRODUCING PROTEIN WHICH IS NECESSARY FOR LAYING EGGS.

IF ALL THE SALT COULD BE EXTRACTED FROM THE SEA AND OCEANS, IT WOULD COMPLETELY COVER THE CONTINENTS WITH A 20-INCH LAYER.

THE MOTTO ON JAMES BOND'S
FAMILY CREST IS,
"THE WORLD IS NOT ENOUGH".

PURE GOLD IS SO SOFT THAT YOU
CAN SHAPE IT WITH YOUR HANDS.

ONE HORSEPOWER IS THE FORCE
NEEDED TO LIFT 75 KILOS ONE METER
STRAIGHT UP IN THE AIR
FOR ONE SECOND.

26 POPES HAVE UNFORTUNATELY BEEN MURDERED.

FOR A LONG TIME, THE TONGA ISLANDS HAD A BANANA SHAPED STAMP.

IF YOU SUFFER FROM ARACHINOPHOBIA, YOU'RE TERRIFIED OF SPIDERS.

GEOGRAPHICAL LOCATIONS WITH THE SHORTEST NAMES ARE "A" IN NORWAY, "O" IN JAPAN AND "Y" IN FRANCE.

IF YOU KEEP A LIVING GOLDFISH IN A COMPLETELY DARK ROOM, IT WILL EVENTUALLY TURN WHITE.

THE HORSEHEAD, USED IN THE FILM *THE GODFATHER*, CAME FROM A FACTORY THAT MANUFACTURES DOG FOOD.

THE A-SYSTEM USED TO KEEP
CONTROL OF PAPER SIZES (A4, A5,
A3 ETC) WAS INVENTED IN GERMANY
IN 1930 AND BECAME
AN INTERNATIONAL STANDARD.

THERE ARE OVER 500 PHOBIAS AND
TAURAPHOBIA IS ONE OF THEM –
A FEAR OF BULLS.

ICE CREAM CONTAINS A THICKENING-
SUBSTANCE EXTRACTED FROM
SEAWEED.

SINCE 1989, OSCAR PRESENTERS ARE NOT ALLOWED TO SAY "AND THE WINNER IS..." THIS INSINUATES THAT ALL OF THE OTHER NOMINEES ARE LOSERS. SO INSTEAD THEY SAY "AND THE OSCAR GOES TO..."

BIRD'S FEET ARE ALWAYS COLD.

THE KOALA GOT ITS NAME FROM THE AUSTRALIAN ABORIGINALS. KOALA MEANS "NO DRINK" AND REFERS TO THE FACT THAT KOALA BEARS GET ALL THE FLUID THEY NEED EATING EUCALYPTUS LEAVES.

ONE OF THE FIRST MOBILE PHONES WITH A BATTERY SMALLER THAN A BAG WAS THE NMT900 PHONE CURT, FROM ERICSSON. IT WEIGHED 1.6 POUNDS AND YOU COULD TALK ON IT FOR 12 MINUTES.

NICHOLAS CAGE CHANGED HIS LAST NAME FROM COPPOLA TO CAGE SO THAT NO ONE WOULD KNOW THAT HE WAS RELATED TO OSCAR-WINNING DIRECTOR FRANCIS FORD COPPOLA, WHO IS HIS UNCLE.

LEPROSY CAN AFFECT ALL PEOPLE BUT ONLY ONE ANIMAL - THE SOUTH AND MIDDLE AMERICAN ARMADILLO.

EVERY YEAR, THE MOON MOVES 1.5 INCHES AWAY FROM THE EARTH.

BRONTOPHOBIA MEANS A TERRIBLE FEAR OF THUNDER.

DIAMONDS ARE MADE OF CARBON AND CAN BURN. IF HEATED UP TO 800°C (1,600°F), DIAMONDS TURN INTO GRAPHITE.

IN THE FAMOUS FILM *CASABLANCA*, RICK (PLAYED BY HUMPHREY BOGART) NEVER ONCE SAID, "PLAY IT AGAIN, SAM".
HE ACTUALLY SAID, "YOU PLAYED IT FOR HER. YOU CAN PLAY IT FOR ME. PLAY IT!" THE LINE "PLAY IT AGAIN, SAM" ACTUALLY COMES FROM THE MARX BROTHER'S FILM *ONE NIGHT IN CASABLANCA*.

A LEECH CAN SUCK UP AS MUCH AS 2 CUBIC CENTIMETERS (0.12 CUBIC INCHES) OF BLOOD, BUT ONLY AFTER FASTING FOR A YEAR.

THE FASTEST ANIMAL IN THE WORLD IS A SWIFT. IT CAN REACH UP TO 98 MILES PER HOUR (168 KM/H).

THE GIVEN NAME "WENDY" FIRST APPEARED IN THE BOOK *PETER PAN.*

AN OLYMPIC SPORT IN 1906 WAS SHOT-PUTTING USING STONES.

BEFORE RONALD REAGAN BECAME A MOVIE STAR, HE WAS A SPORTS COMMENTATOR.

LEONARDO DICAPRIO'S FIRST APPEARANCE IN FRONT OF A CAMERA WAS IN A COMMERCIAL FOR MILK.

THE HEART OF AN EMBRYO STARTS BEATING THREE WEEKS AFTER CONCEPTION.

A BLUE WHALE'S PENIS IS BETWEEN 15 – 20 FEET LONG.

THE MOST COMMON DISEASE TO PLAGUE HUMANS IS "CORYZA", BETTER KNOWN AS "THE COMMON COLD". IT HAS SPREAD ALMOST EVERYWHERE ON EARTH.

THE SMALLEST COUNTRY IN THE WORLD IS THE VATICAN IN ROME. IT'S ONLY 0.17 SQUARE MILES.

THE LARGEST CELL IN THE HUMAN BODY IS THE FEMALE EGG.

R2-D2, THE POPULAR ROBOT FROM THE *STAR WARS MOVIES*, IS CALLED C1-P8 IN THE ITALIAN MOVIE VERSIONS.

PAUL SIMON AND ART GARFUNKEL WERE CLASSMATES.

YOU CAN'T SNEEZE IN YOUR SLEEP.

THE ELEMENT CALIFORNIUM IS NAMED AFTER THE AMERICAN STATE, CALIFORNIA.

DUMDUM BULLETS ARE NAMED AFTER THE CITY WHERE THE AMMUNITION IS MANUFACTURED, DUMDUM, INDIA.

A SIFONAPTOROLOGIST STUDIES FLEAS.

THE WEIGHT OF AN ADULT PERSON'S SKIN IS ABOUT 6.6 POUNDS.

TOM JONES PUT SO MUCH FEELING INTO A SONG HE RECORDED FOR THE JAMES BOND FILM *THUNDER BALL*, THAT HE BLACKED OUT IN THE STUDIO.

THE FIRST CERVICAL VERTEBRA ON HUMANS IS CALLED ATLAS.

VENUS, THE SECOND PLANET IN OUR SOLAR SYSTEM, ROTATES IN THE OPPOSITE DIRECTION OF THE OTHER EIGHT PLANETS.

IN THE BAHAMAS THERE ARE DIFFER-ENT CLASSIFICATIONS FOR STRONG WINDS. ONE IS "THE BANANA WIND" – THIS MEANS THE WIND IS SO STRONG, BANANAS ON THE TREES FALL TO THE GROUND.

THE 'PONT NEUF' (WHICH TRANSLAT-
ED MEANS 'NEW BRIDGE') IS ACTUAL-
LY THE OLDEST BRIDGE IN PARIS.

A LLAMA CAN SPIT 16.5 FEET.

A NORMAL HUMAN BRAIN CONTAINS
AS MANY BRAIN CELLS AS THERE
ARE STARS IN THE MILKY WAY;
ABOUT 100 MILLION.

THE THREADS IN NYLON STOCKINGS
ARE FIVE TIMES THINNER THAN
HUMAN HAIR.

OTHER SUGGESTED NAMES FOR THE
TV SERIES *MONY PYTHON'S FLYING
CIRCUS WERE:*
GWEN DIBLEY'S FLYING CIRCUS,
OWL-STRETCHING TIME,
*BUN, WHACKETT, BUZZARD, STUBBLE
AND BOOT,*
A TOAD ELEVATING MOMENT,
SEX AND VIOLENCE,
A HORSE, A BUCKET AND A SPOON.

THERE ARE OVER 500 RECOGNIZED
PHOBIAS. ONE OF THE MOST RARE
IS SCIOPHOBIA
– THE FEAR OF SHADOWS.

GERMS ARE VERY SMALL. ONE
SINGLE WATER DROPLET CAN
CONTAIN UP TO 50 MILLION GERMS.

THE ONLY VISIBLE HUMAN
MUSCLE IS THE TONGUE.

THERE IS A VERY UNUSUAL DIALECT
ON NEW GUINEA CALLED TAKI.
IT ONLY CONTAINS 340 WORDS.

DURING ONE SINGLE SOCCER MATCH, A PROFESSIONAL PLAYER CAN MOVE A DISTANCE OF 7 MILES.

GEORGE CLOONEY'S FIRST STARRING ROLE WAS A MINOR PART IN THE FILM *RETURN OF THE KILLER TOMATOES.*

CLEOPATRA COULD SPEAK 13 LANGUAGES.

THE ALBATROSS CAN
FLY WHILE SLEEPING.

THE NOTION OF COUNTING BACKWARDS - AS DONE DURING A SPACE ROCKET LAUNCH, FOR EXAMPLE – ORIGINATED FROM A GERMAN SCIENCE FICTION FILM. THE DIRECTOR THOUGHT THAT THE COUNTDOWN WOULD INCREASE THE THRILL.

TAPEWORMS ARE CAPABLE OF GROWING VERY LONG. THE LONGEST THAT FAVORS LIVING INSIDE HUMANS IS THE TAENIA SAGINATA. FEMALES CAN REACH UP TO 80-FEET.

THE WEAKEST MUSCLE IN THE HUMAN BODY IS THE STAPEDIUS MUSCLE WHICH IS LOCATED IN THE MIDDLE EAR. ITS ONLY FUNCTION IS TO MOVE THE 3 MILLIMETERS (1/8-INCH) STIRRUP BONE A 1/2-MILLIMETER (1/16-INCH).

KHMER IS THE WORLD'S LONGEST ALPHABET. IT CONTAINS 74 CHARAC-TERS AND IS USED BY ABOUT 8 MILLION PEOPLE IN CAMBODIA.

98% OF OUR GENES ARE THE SAME AS A CHIMPANZEES. ONLY 2% MAKE US A DIFFERENT SPECIES.

KISSING IS NOT ONLY NICE. IT'S ALSO GOOD FOR YOUR TEETH! IT'S BECAUSE WHEN YOU KISS, YOUR MOUTH PRODUCES SALIVA AND SALIVA HELPS PROTECT AGAINST DENTAL PLAQUE.

THE FOUR RINGS ON JELLYFISH ARE SEX ORGANS. THE MALE'S RINGS ARE WHITE ONES WHILE THE FEMALE ALSO HAS ADDITIONAL RED ONES.

OUR BLOOD CIRCULATION IS VERY LONG. THE BLOOD VESSELS, ALL TOGETHER, ARE BETWEEN 3,000 AND 6,000 MILES LONG.

A KOMODO DRAGON CAN EAT
ONE AND A HALF TIMES ITS OWN
BODY WEIGHT IN JUST A COUPLE
OF MINUTES.

MACH 1 IS THE TECHNICAL TERM
FOR THE SPEED OF SOUND – 742
(STATUTE) MILES PER HOUR.

THE EARTH CIRCLES AROUND
THE SUN AT A SPEED OF
18.6 MILES PER SECOND.

A CONCORDE HOLDS 31,510 GALLONS
OF PETROL IN ITS TANKS.

BEARS CAN BE LEFT OR
RIGHT HANDED.

YOU SHARE THE SAME BIRTHDAY
WITH ABOUT 9 MILLION OTHER
PEOPLE.

THE WINGS ON A BANANA FLY FLAP
BACK AND FORTH 200 TIMES PER
SECOND.

120 MILLIGRAMS OF ARSENIC
IS ENOUGH TO KILL YOU.

WHEN PHARMACIST JOHN PEMBER-
TON WAS MIXING THE SOLUTION
THAT LATER WAS TO BECOME
COCA-COLA, HE INCLUDED IN HIS
EXPERIENTAL BATCHES COCAINE,
COCA LEAVES AND COLA NUTS.

THELMA PICKLES WAS JOHN
LENNON'S FIRST GIRLFRIEND.

**WINSTON CHURCHILL WAS
BORN IN A LADIES LAVATORY.**

**THE CHAMELEON HAS A TONGUE
LONGER THAN ITS OWN BODY.**

**IN 1999; THE DANISH MOVIE *FESTEN*
RECEIVED A PECULIAR FILM AWARD
IN GERMANY FOR THE WORST
DUBBED MOVIE.**

IF YOU CUT OFF A COCKROACH'S HEAD, IT CAN LIVE FOR NINE MORE DAYS UNTIL IT STARVES TO DEATH.

THE ELECTRIC CHAIR WAS INVENTED BY A DENTIST.

DURING A FLIGHT, THE CONCORDE GETS 7 TO 8-INCHES LONGER. THE HEAT FROM THE FRICTION CAUSES THE METAL TO EXPAND.

THERE ARE MORE THAN 30,000 DIFFERENT KINDS OF ROSES.

THE GERMAN FRIEDRICH SERTÜNER, WHEN HE MANAGED TO ISOLATE THE ACTIVE SUBSTANCE FROM OPIUM IN 1806, GAVE THE SUBSTANCE THE NAME "MORPHINE" AFTER THE GREEK GOD OF SLEEP.

THE KOALA IS LOVED BY CHILDREN ALL OVER THE WORLD. BUT DID YOU KNOW THAT IT´S ONE OF THE SLEEPIEST ANIMALS IN THE FAUNA? THE KOALA SPENDS 22 HOURS EVERY DAY SLEEPING.

THE SHORTEST KNOWN ALPHABET IS
NEW GUINEA'S ROTOKAS. IT HAS
ONLY 11 LETTERS –
A, B, E, G, I, K, O, P, R, T AND U.

DR. ALEXANDER WOODS INVENTED
THE HYPODERMIC SYRINGE IN 1882.

IN JAPANESE, THE WORDS FOR
"FOUR" AND "DEAD" ARE
PRONOUNCED EXACTLY THE SAME.
THIS IS ALSO TRUE FOR "NINE" AND
"PAIN". THIS EXPLAINS WHY NO
HOTEL ROOMS IN JAPAN HAVE THE
NUMBERS 4 OR 9.

IF YOU FILL A CONE-SHAPED DRAM
GLASS HALFWAY, IT'S ACTUALLY
ONLY FILLED 12 – 13%.

HAVE YOU EVER TRIED TO LICK
YOUR OWN ELBOW? EVEN IF YOU
TRY, YOU WILL NEVER SUCCEED.
IT'S PHYSICALLY IMPOSSIBLE TO DO.

PHRENOLOGY IS AN OLD SCIENCE
THAT ADVOCATES THAT ONE CAN
UNDERSTAND THE CHARACTERISTICS
OF A PERSON BY THE SHAPE OF
THEIR SKULL.

THE AFRICAN OSTRICH LAYS THE LARGEST EGGS IN THE WORLD. THE SHELL IS 1.5 MILLIMETERS THICK AND IS STRONG ENOUGH TO HOLD THE WEIGHT OF AN ADULT MAN.

ANOTHER RARE PHOBIA IS
LUTRAPHOBIA; –
A DEATHLY FEAR OF OTTERS.

THE TALLEST PICASSO STATUE IN
THE WORLD CAN BE FOUND IN
KRISTINEHAMN, SWEDEN.

THE QUARTZ CRYSTAL IN A DIGITAL WATCH VIBRATES 32,768 TIMES EVERY SECOND.

STEVEN SPIELBERG DIDN'T ACCEPT ANY MONEY FOR THE FILM *SCHINDLER'S LIST*. HE FELT IT WOULD BE BLOOD MONEY.

THE SEVEN BEAMS IN THE CROWN OF THE STATUE OF LIBERTY REPRESENT THE SEVEN SEAS AND SEVEN CONTINENTS.

MONEY CONTAINS COTTON AS WELL AS PAPER. THAT'S WHY IT CAN SURVIVE A TUMBLE THROUGH THE WASHING MACHINE.

SHARKS ARE THE ONLY FISH THAT CAN BLINK BOTH EYES SIMULTANEOUSLY.

A SHARK'S SKELETON IS NOT MADE OF BONE LIKE OTHER FISH AND VERTEBRATES. INSTEAD, IT IS MADE-UP OF CARTILAGE.

THE ACTOR DOLPH LUNDGREN HAS A UNIVERSITY DEGREE FROM THE ROYAL TECHNICAL UNIVERSITY OF STOCKHOLM.

THE TUTSIS IN CONGO, AFRICA, ARE THE TALLEST PEOPLE
IN THE WORLD. MANY ARE 7 FEET TALL. THEY LIVE NEXT TO THE PYGMIES WHO ARE THE SHORTEST PEOPLE IN THE WORLD.

RHINOCEROS' HORNS ARE MADE UP OF COMPRESSED HAIR.

ORIGINALLY, COCA-COLA WAS SOLD AS A PRESCRIPTION TO CURE MELANCHOLY, HYSTERIA AND MIGRAINES.

THE SOHO AREA OF NEW YORK CITY IS NAMED SOHO BECAUSE IT IS LOCATED SOUTH OF HOUSTON STREET.

THE NATIONAL ANTHEM OF GREECE CONTAINS 158 VERSES.

THE PIG IS THE ONLY ANIMAL THAT, LIKE HUMANS, CAN GET A SUNTAN.

THE WORLD'S LONGEST CITY NAME HAS 167 CHARACTERS.

KRUNGTHEPMAHANAKORNAMORNRAT-
TANAKOSINMAHINTARAYUTTHAYAMA-
HADILOKPHOPNOPARATR
JATHANIBURIROMUDOMRAJANIWESMA-
HASATHARNAMORNPHIMARNAVATARN-
SATHITSAKKATATTIYAVISANUKAMPRA-
SIT.

IT TRANSLATES INTO: THE GREAT CITY OF ANGELS, THE SUPREME UNCONQUER-ABLE LAND OF THE GREAT IMMORTAL DIVINITY, THE ROYAL CAPITAL OF NINE NOBLE GEMS, THE PLEASANT CITY, WITH PLENTY OF GRAND ROYAL PALACES, AND DIVINE PARADISES FOR THE REINCAR-NATED DEITY, GIVEN BY INDRA AND CRE-ATED BY THE GOD OF CRAFTING. IT IS KNOWN TO THE REST OF THE WORLD AS BANGKOK, THAILAND.

BRUCE WILLIS IS LEFT-HANDED. TO GET A BETTER CAMERA ANGLE, IN THE FILM SIXTH SENSE, HE WROTE WITH HIS RIGHT HAND IN ONE SCENE.

GRAMPUS, A PLAYFUL, BLACK AND WHITE DOLPHIN, CAN LIVE TO THE RIPE OLD AGE OF 80 TO 90 YEARS.

IT TAKES 240 MILLION YEARS FOR OUR SOLAR SYSTEM TO TRAVEL AROUND THE CENTER OF OUR GALAXY, THE MILKY WAY. THIS IS KNOWN AS A COSMIC YEAR.

SOME OF THE LARGER BATTLE SCENES IN THE FILM *BRAVEHEART* HAD TO BE DONE TWICE, BECAUSE MANY PEOPLE WITH WALK-ON PARTS COULD BE SEEN WEARING WATCHES AND SUNGLASSES.

ANTOINE SAINT-EXUPÉRY, THE FRENCH AUTHOR WHO WROTE *THE LITTLE PRINCE*, DIED WHEN HIS SMALL PLANE CRASHED ON JULY 31, 1944. WHY THE PLANE CRASHED IS STILL UNKNOWN.

A MULE IS THE SPAWN OF A DONKEY AND A MARE.

COULFOPHOBIA IS THE TECHNICAL TERM FOR A FEAR OF CLOWNS.

STAR TREK, THE FAMOUS TV SERIES, WAS NOT A HIT WHEN IF FIRST STARTED. AFTER ONLY TWO SEASONS, THE TV NETWORK WANTED TO CANCEL IT.

WRIGLEY'S, THE AMERICAN CHEWING GUM, WAS THE FIRST PRODUCT IN THE WORLD WITH A BAR CODE.

IF YOU SUFFER FROM POLYDACTYL,
YOU WERE BORN WITH MORE THAN
10 FINGERS AND TOES.

THE NOBEL PRIZEWINNER MARIE
CURIE WAS THE FIRST WOMAN
ALLOWED TO TEACH AT THE
UNIVERSITY OF SORBONNE IN PARIS.

A LIGHTNING BOLT WILL HEAT UP THE
AIR AROUND IT TO ABOUT 3,000°C
(5432 DEGREES FAHRENHEIT).

IN AN EARLIER VERSION OF THE
SCRIPT FOR THE FILM *ALIEN*,
RIPLEY WAS SUPPOSED TO BE
PLAYED BY A MAN.

DURING THE FIRST WORLD WAR,
JOSEF STALIN GOT OUT OF SERVING
HIS MILITARY SERVICE BECAUSE OF
HIS DEFORMED FEET. HE HAD TWO
TOES THAT WERE GROWN TOGETHER.

A DRAGONFLY CAN FLY BACKWARDS
AS FAST AS IT CAN FLY FORWARDS.

THE PITOHUIS, A GROUP OF BIRDS IN NEW GUINEA, HAVE POISONOUS FEATHERS AND SKIN. WHEN PREDATORS CATCH ONE OF THESE BIRDS, THEY INSTINCTIVELY SPIT IT OUT.

IF YOU LOVE COFFEE AND DRINK 100 CUPS IN FOUR HOURS, YOU WILL PROBABLY DIE FROM CAFFEINE POISONING.

BEFORE MICHAEL CAINE AND CHER CHANGED THEIR NAMES, THEY ANSWERED TO MAURICE MICKLEWHITE AND CHERILYN SARKISIAN LA PIERE.

ONLY TWO OF YOUR MOUTH MUSCLES
ARE REQUIRED FOR CREATING A
SMILE UNLESS YOU CONSIDER
THE MANY MUSCLES AROUND YOUR
EYES AS WELL.

MEN AND WOMEN BUTTON THEIR
SHIRTS DIFFERENTLY. A PRACTICE
THAT COMES FROM OLDEN TIMES
WHEN ROYAL MEN DRESSED
THEMSELVES BUT THE WOMEN USED
CHAMBERMAIDS WHO BUTTONED
THEIR BLOUSES FOR THEM FROM
THE FRONT.

THE LANGUAGE WITH THE GREATEST
NUMBER OF WORDS IS ENGLISH. IT
CONTAINS MORE THAN 455,000
ACTIVE WORDS AND 700,000
DEAD WORDS.

RAW ASPARAGUS IS
SLIGHTLY POISONOUS.

ARNOLD SCHWARZENEGGER RECEIVED
A COOL 15 MILLION DOLLARS FOR HIS
PART IN *TERMINATOR 2*, WHERE HE
ONLY SPOKE 700 WORDS. THAT'S
$21,429 PER WORD. THE CLASSIC
PHRASE "HASTA LA VISTA, BABY"
EARNED HIM $85,716.

GHANDI'S FULL NAME WASN'T MAHATMA GANDHI. HIS REAL NAME WAS MOHANDAS KARAMCHAND GANDHI. MAHATMA WAS A TITLE OF HONOUR WHICH MEANS LARGE SPIRIT.

THE TOOLS THAT WERE USED TO FIX UP JACK NAPIER (JACK NICHOLSON) AFTER HIS CHEMICAL BATH IN *BATMAN* ARE THE SAME TOOLS USED BY THE SADISTIC DENTIST, ORIN SCRIVELLO (STEVE MARTIN), IN THE 1986 FILM *LITTLE SHOP OF HORRORS*.

ON A FLIGHT FROM ANTWERP
TO LONDON IN 1997, 21 OF THE
PASSENGERS WERE 100 YEARS OLD.

MOST FISH STAY AWAKE MOST OF
THEIR LIVES. HOWEVER, THERE ARE
FISH THAT SLEEP. THEY LEAN
AGAINST A ROCK OR STAND
VERTICALLY IN THE WATER.

A SNAIL CAN SLEEP
FOR THREE YEARS.

MOSQUITOES CAN TRACK PEOPLE UP TO 110 YARDS AWAY BY THE SUBSTANCES IN THEIR BREATH.

THE LARGEST PAINTING IN THE WORLD IS *THE BATTLE AT GETTYS-BURG*, CREATED BY THE AMERICAN PAUL PHILLIPOTEAUX AND 16 OF HIS ASSISTANTS. IT STANDS 68.8-FEET HIGH AND IS 410-FEET WIDE.

THE TYRANNOSAURUS REX SUFFERED FROM GOUT.

THERE ARE 336 DIMPLES
IN A GOLF BALL.

THE MOST WIDELY USED LANGUAGE IN THE WORLD IS MANDARIN-CHINESE, THE MOTHER TONGUE FOR ALMOST 900 MILLION PEOPLE. ONLY 332 MILLION PEOPLE HAVE ENGLISH AS THEIR MOTHER TONGUE.

TO PRODUCE 1 SINGLE GRAM OF SERUM, YOU NEED POISON FROM 150 COBRA BITES.

ALFRED NOBEL'S BROTHER EMIL, DIED IN AN EXPLOSION IN THE LABORATORY WHERE BOTH BROTHERS WERE PERFORMING EXPERIMENTS WITH EXPLOSIVE OILS, THE FORERUNNER TO DYNAMITE.

IF ALL THE RAIN IN OUR ATMOSPHERE FELL AT THE SAME TIME, IT WOULD COVER THE EARTH WITH A ONE-INCH THICK LAYER OF WATER.

THE CENTRE OF THE SUN IS 15 MILLION DEGREES CELSIUS. THE SURFACE IS ONLY 5,800 DEGREES CELCIUS (10472 DEGREES FAHRENHEIT).

THE SALT IN YOUR TEARS COMES FROM THE FOOD YOU EAT. IT´S TRANSPORTED VIA THE BLOOD CIRCULATION TO THE LACRIMAL GLAND NEAR YOUR EYES WHERE TEARS ARE PRODUCED.

IF YOU SUFFER FROM DENTOPHOBIA, YOU HAVE AN EXTREME FEAR OF DENTISTS.

JONATHAN FRAKES REFUSED TO SHAVE HIS BACK IN THE LOVE SCENE WITH MARTINA MARTIS IN THE FILM *STAR TREK: NEMESIS*. THE HAIR HAD TO BE DIGITALLY REMOVED.

THE BLACK AND WHITE LINES FOUND
ON A BAR CODE, SYMBOLIZE DIFFER-
ENT NUMBERS.
TOGETHER THEY FORM A LONG CODE
THAT CONTAINS ALL NECESSARY
DATA FOR A PRODUCT.

THE BIGGEST DIFFERENCE BETWEEN
AN "EBB" AND A "FLOOD" WAS
MEASURED IN NOVA SCOTIA,
CANADA'S BAY OF FUNDY.
THE DIFFERENCE WAS 52 FEET.

ICHTHYOSAURS, SEA DWELLING DINOSAURS, LIVED DURING THE JURASIC PERIOD AND HAD EYES 9-INCHES WIDE.

THE PINK OR RED COLOR ON FLAMIN-GOS INDICATES THAT THE BIRD HAS BECOME SEXUALLY MATURE. THEY'RE WHITE WHEN THEY ARE BORN BUT AFTER A YEAR THEY GET THEIR COLOR.

**BARBIE'S FULL NAME IS
BARBARA MILLICENT ROBERTS.**

**THE SONG OF A HUMPBACK WHALE
CAN REACH 190 DB. THAT'S
EQUIVALENT TO THE SOUND OF
A BOEING 747 AT TAKEOFF.**

**BEFORE JOSEF STALIN BECAME A
REVOLUTIONIST, HE CONSIDERED
A CAREER AS A PRIEST. HE WAS
THROWN OUT OF SEMINARY,
THOUGH, BECAUSE OF HIS DRINKING
AND AGGRESSIVE BEHAVIOUR.**

WALT DISNEY WAS AFRAID OF MICE.

TWENTY PERCENT OF THE WORLD'S POPULATION HAS A GENETIC DISORDER THAT CAUSES THE LACK OF WISDOM TEETH.

COCO WATER, THE FLUID IN YOUNG, TINY COCONUTS, CAN BE USED AS A SUBSTITUTE FOR BLOOD PLASMA.

THE LARGEST KNOWN SHARK IS
THE GREAT WHITE SHARK.
IT CAN BECOME 46 FEET LONG.

THE AVERAGE CAR STANDS
STILL 23 HOURS OF THE DAY.

50% OF ALL BANK ROBBERIES
ARE DONE ON FRIDAYS.

200 CHILDREN ARE BORN
EVERY MINUTE.

ALEXANDER GRAHAM BELL, WHO INVENTED THE TELEPHONE, COULD NEVER TALK TO HIS MOTHER OR WIFE ON IT. THEY WERE BOTH DEAF.

ALFRED HITCHCOCK HAD NO BELLY BUTTON.

A SHRIMP'S HEART IS LOCATED IN ITS HEAD.

IN AN 80-YEAR-LONG STUDY ON
200,000 OSTRICHES,
NOT A SINGLE CASE WAS REPORTED
WHERE AN OSTRICH BURIED ITS HEAD
IN THE GROUND.

IT IS PHYSICALLY IMPOSSIBLE FOR
A PIG TO LOOK UP AT THE SKY.

MORE THAN 50% OF THE WORLD'S
POPULATION HAS NEVER MADE
OR RECEIVED A TELEPHONE CALL.

HORSES CAN´T THROW UP.

THE MOST DIFFICULT WORDS TO SAY FAST IN ENGLISH ARE "SIXTH SICK SHEIK'S SIXTH SHEEP'S SICK".

RATS CAN BREED SO FAST THAT AFTER ONLY EIGHTEEN MONTHS THEY CAN PRODUCE MORE THAN A MILLION OFF-SPRING.

IF YOU USE EARPHONES FOR ONE HOUR, YOU WILL INCREASE THE AMOUNT OF BACTERIA IN YOUR EARS BY 700%.

23% OF ALL COPY MACHINE BREAK-DOWNS COME FROM PEOPLE SITTING ON THEM TO MAKE COPIES OF THEIR OWN BUTTS.

NEARLY ALL LIPSTICKS CONTAIN FISH SCALES.

NO PAPER CAN BE FOLDED IN HALF MORE THAN 7 TIMES.

IN ONE YEAR, AMERICAN AIRLINES SAVED $40,000 BY DECREASING THE NUMBER OF OLIVES BY JUST ONE ON EACH FIRST-CLASS SALAD.

YOU BURN MORE CALORIES SLEEPING THAN WATCHING TV.

THE KING OF HEARTS IS THE ONLY KING WITHOUT A MOUSTACHE.

MOST OF THE DUST IN YOUR HOME COMES FROM YOUR OWN DEAD SKIN CELLS.

IN ONE YEAR BASKETBALL ICON, MICHAEL JORDAN, EARNED MORE MONEY FROM HIS SPONSOR, NIKE, THAN ALL OF THE EMPLOYEES PUT TOGETHER AT THE MALAYSIA NIKE FACTORY.

RICHARD MILHOUSE NIXON WAS THE FIRST AMERICAN PRESIDENT WHOSE NAME INCLUDED ALL THE LETTERS IN THE WORD "CRIMINAL".

TURTLES CAN BREATHE THROUGH THEIR BUTTS.

ACCORDING TO THE OXFORD ENGLISH DICTIONARY, THE LONGEST ENGLISH WORD IS PNEUMONOULTRAMICRO-SCOPICSILICOVOLCANOKONIOSIS. THE FORTY-FIVE-LETTER WORD IS THE NAME OF A SPECIAL FORM OF SILICOSIS CAUSED BY ULTRAMICRO-SCOPIC PARTICLES OF SILICA VOLCANIC DUST...

INGROWN NAILS ARE HEREDITARY.

THE LONGEST GEOGRAPHICAL NAME STILL IN USE IS THE NAME OF A HILL IN NEW ZEALAND. IT'S CALLED TAUMATAWHAKATANGIHA NGAKOAUAUOTAMATEATURIPUKAKA-PIKIMAUNGAHORONUKUPOKAIWE NUAKIT NATAHU.

TELLY SAVALAS AND LOUIS ARMSTRONG BOTH DIED ON THEIR BIRTHDAYS.

DONALD DUCK'S MIDDLE NAME IS FAUNTLEROY.

THE INITIALS FOR THE RUSSIAN SECRET SERVICE "KGB" STAND FOR KOMITET GOSUDARSTVENNOY BEZOPASNOSTI.

THE KANGAROO AND EMU CAN'T MOVE BACKWARDS. THAT'S WHY THEY HAVE BEEN CHOSEN AS SYMBOLS FOR THE AUSTRALIAN CONTINENT.

GORDON SUMNER, THE ROCK STAR ALSO KNOWN AS STING, GOT HIS NICKNAME FROM THE YELLOW-BLACK T-SHIRTS HE USED TO WEAR. THE OTHER BAND MEMBERS THOUGHT HE LOOKED LIKE A BUMBLEBEE.

TASTE BUDS ONLY LIVE FOR 10 DAYS.

UNTIL 1890, THE CHOIR BOYS IN THE VATICAN WERE CASTRATED TO PREVENT THEIR VOICES FROM BECOMING DEEPER.

RESEARCH SHOWS MOSQUITOES LIKE PEOPLE WHO HAVE RECENTLY EATEN BANANAS.

A CAT HAS A LARGER CHANCE OF SURVIVING A FALL FROM THE 20TH FLOOR THAN FROM THE 7TH FLOOR.

IF NASA DECIDED TO SEND BIRDS UP IN SPACE, THE BIRDS WOULD SOON DIE. THEY NEED GRAVITY TO SWALLOW.

EVERY TIME YOU LICK A STAMP, YOU WILL EAT ONE TENTH OF A CALORIE.

ON AVERAGE, AN ADULT LAUGHS 15 TIMES A DAY WHILE A BABY LAUGHS 400 TIMES A DAY.

$$111,111,111 \times 111,111,111 = 12,345,678,987,654,321$$

ONE LEG OF A DOVE WEIGHS LESS
THAT ITS FEATHERS.

YOUR HEARING IS BETTER WHEN YOU
ARE HUNGRY THAN WHEN YOU'VE
JUST EATEN.

THE MOST COMMON REPORTED
TIME TO SEE A UFO IS AT 2300
HOURS (11 PM).

THERE ARE 31,557,600 SECONDS IN A YEAR.

IF A SQUID IS EXTREMELY HUNGRY, IT CAN EAT ITS OWN ARMS.

THE GREATEST AMOUNT OF BACTERIA ON YOUR BODY IS HIDDEN BETWEEN YOUR TOES.

DID YOU KNOW THAT THE YO-YO IS THE OLDEST TOY, AFTER THE DOLL?

THE WORD "WAR" IN SANSKRIT
MEANS "WISH FOR MORE COWS".

KANGAROOS ARE
LACTOSE INTOLERANT.

ACCORDING TO THE LAW OF
MASSACHUSETTS, GOATS ARE
NOT ALLOWED TO WEAR PANTS.

**THIS YEAR YOU WILL BLOW
YOUR NOSE 250 TIMES.**

MOSQUITOES HAVE 47 TEETH.

**IN THE CITY OF LAWRENCE, KANSAS,
IT'S AGAINST THE LAW TO WALK
AROUND WITH BEES IN YOUR HAT.**

ONLY 30% OF ALL HUMAN BEINGS CAN FLARE THEIR NOSTRILS.

MORE THAN 250 PEOPLE HAVE FALLEN FROM THE LEANING TOWER OF PISA SINCE THE YEAR 1174.

IN ANCIENT EGYPT, THE PENALTY FOR KILLING A CAT WAS DEATH.

ACCORDING TO AN 1845 BRITISH LAW
- IF YOU ATTEMPTED TO COMMIT
SUICIDE, YOU WERE SENTENCED
TO DEATH.

ONCE UPON A TIME, CHRISTMAS WAS
FORBIDDEN IN ENGLAND.

IN HARTFORD, CONNECTICUT YOU ARE
NOT ALLOWED TO KISS YOUR WIFE
ON SUNDAYS.

IN KENTUCKY, IT'S AGAINST THE LAW
TO WALK AROUND WITH ICE CREAM
IN YOUR HIP POCKET.

SINCE 1916, WHEN A MAN MAILED A
40,000 TON BRICK HOUSE IN ORDER
TO AVOID HIGH FREIGHT COSTS, IT IS
FORBIDDEN TO SEND A WHOLE BUILD-
ING BY MAIL IN THE UNITED STATES.

A FULLY LOADED OIL TANKER
NEEDS 20 MINUTES TO STOP.

ALL SUNLIGHT THAT HITS THE SURFACE OF THE EARTH DURING ANY GIVEN MOMENT, WEIGHS AS MUCH AS A CRUISE SHIP.

WHEN THE ATOMIC BOMB WAS DEVELOPED IN THE AMERICAN CITY OF LOS ALAMOS, NEW MEXICO, THE MILITARY BASE PREFERRED STAFF THAT WERE ILLITERATE AS THE AUTHORITIES DIDN'T WANT THE RISK OF HAVING WORKERS THAT COULD READ CONFIDENTIAL PAPERS FROM THE WASTE BINS.

EVERY YEAR, 4,000 PEOPLE ARE
INJURED BY TEA POTS.

ALL HOSPITALS IN SINGAPORE
USE PAMPERS DIAPERS.

COLGATE HAD A BIG CHALLENGE
WHEN THEY RELEASED THEIR TOOTH
PASTE IN SPANISH SPEAKING
COUNTRIES. COLGATE MEANS
"GO HANG YOURSELF" IN SPANISH.

ON AVERAGE, THERE ARE 333 PIECES OF TOILET PAPER ON ONE TOILET ROLL.

YOUR BODY CONTAINS ABOUT 100,000,000,000,000 CELLS.

NO AMERICAN PRESIDENT HAS HAD BROWN EYES.

**THE ONLY PART OF YOUR BODY
THAT CAN'T GET CANCER,
IS THE LENS OF THE EYE.**

**FEMALE HYENAS HAVE
UNDERDEVELOPED PENISES.**

**THE DISTANCE BETWEEN THE
SURFACE AND THE CENTER OF THE
EARTH IS 3,700 MILES.**

**BOWLING WAS INVENTED
IN EGYPT AROUND 5,000 B.C.**

**DALMATIANS ARE BORN
WITHOUT SPOTS.**

**DOLPHINS ALWAYS KEEP ONE
EYE OPEN WHILE SLEEPING.**

EUROPE AND NORTH AMERICA ARE
DRIFTING APART AT THE SAME SPEED
IT TAKES OUR NAILS TO GROW.

LEONARDO DA VINCI COULD WRITE
WITH ONE HAND AND PAINT WITH
THE OTHER – SIMULTANEOUSLY.

THERE ARE NO CLOCKS IN LAS VEGAS
CASINOS.

**THE HOTTEST PLACE ON EARTH
IS EL AZIZIA IN LIBYA.**

**RIGHT-HANDED PEOPLE LIVE APPROX-
IMATELY 9 YEARS LONGER THAN
LEFT-HANDED PEOPLE.**

**IN ONE YEAR,
MORE MONOPOLY MONEY
IS PRINTED THAN REAL MONEY.**

EVERY CHOCOLATE BAR PRODUCED
CONTAINS AN AVERAGE OF
8 INSECT LEGS.

A POLAR BEAR'S SKIN IS BLACK.

ELVIS HAD A TWIN BROTHER
WHO DIED AT BIRTH. HIS
NAME WAS JESSE GARON.

IN CHINA, THERE ARE MORE PEOPLE
WHO SPEAK ENGLISH THAN IN
THE USA.

IF ALL THE INHABITANTS OF CHINA
WALKED PAST YOU IN A SINGLE LINE,
THE LINE WOULD NEVER STOP IF YOU
TAKE INTO CONSIDERATION THE RATE
OF REPRODUCTION.

ANTS ALWAYS FALL ON THEIR
RIGHT SIDE IF THEY GET DRUNK.

IF YOU WERE TO SELL EVERY USEFUL
PART OF YOUR BODY, YOU WOULD
GET APPROXIMATELY $35 MILLION
DOLLARS.

THE WORLD RECORD FOR AN
UNDERWATER KISS IS 2 MINUTES
AND 18 SECONDS.

5% OF ALL ADULTS SLEEPWALK.

A GOOD BUTLER SHOULD CHANGE
SHOES EVERY THREE HOURS.

ADOLF HITLER'S FAVOURITE MOVIE
WAS *KING KONG*.

IT WOULD TAKE 1.12 MILLION
MOSQUITOES, STINGING YOU ALL AT
THE SAME TIME, TO COMPLETELY
EMPTY YOUR BODY OF ITS BLOOD.

ONE OF THE REASONS FIDEL CASTRO GREW A BEARD WAS THAT THE EMBARGOES FROM THE USA MADE IT DIFFICULT TO GET RAZOR BLADES.

IT TAKES AN ADULT ABOUT 138 MINUTES TO WATCH *BRIDGES OVER MADISON COUNTY* BUT ONLY 118 MINUTES TO READ THE BOOK.

THE GLUE ON STAMPS IN ISRAEL IS KOSHER APPROVED.

"DNA" STANDS FOR
DEOXYRIBONUCLEIC ACID.

THE SCIENTIFIC WORD FOR
PICKING ONE'S NOSE IS
RHINOTILLEXONAMIA.

SYLVESTER STALLONE ONCE WORKED
IN A CIRCUS CLEANING LION CAGES.

MICHAEL JACKSON'S SONG *BILLY JEAN* WAS THE FIRST MUSICAL VIDEO SHOWN ON MTV THAT WAS MADE BY AN AFRICAN-AMERICAN PERFORMER.

AN AIRPORT IN ENGLAND USES SONGS BY TINA TURNER TO SCARE BIRDS OFF THE RUNWAY.

IN 1938, ADOLF HITLER WAS ELECTED *TIME* MAGAZINE'S "MAN OF THE YEAR".

WHEN ALBERT EINSTEIN DIED,
HIS BRAIN WAS PUT IN A JAR TO
BE EXAMINED AND SAVED FOR
THE FUTURE.

IN 1978, EMILIO MARCO PALMA WAS
THE FIRST PERSON TO BE BORN IN
THE ANTARCTIC.

ON AVERAGE 7.5% OF ALL OFFICE
DOCUMENTS DISAPPEAR.

BILL GATES BEGAN PROGRAMMING
COMPUTERS WHEN HE WAS
13 YEARS OLD.

IN THE USA, YOUNG PEOPLE BUY
$40 MILLION DOLLARS' WORTH
OF CHEWING GUM EVERY YEAR.

NEARLY EVERY PHOTO ADVERTISING
A WATCH SHOWS THE TIME TO BE
10:10.

SINGLE PEOPLE ARE SEVEN AND A HALF TIMES MORE LIKELY TO REQUIRE PSYCHIATRIC CARE.

DURING A LIFETIME, YOU WILL PRODUCE ENOUGH SALIVA TO FILL TWO SWIMMING POOLS.

ON AVERAGE, A FOUR-YEAR OLD CHILD WILL ASK 437 QUESTIONS EVERY DAY.

NOBODY KNOWS WHY, BUT 90%
OF ALL WOMEN WALK DIRECTLY
TO THE RIGHT WHEN THEY ENTER
A DEPARTMENT STORE.

IN NEW YORK, 311 PERSONS GET
BITTEN BY RATS EVERY YEAR. 1519
PERSONS ARE BITTEN BY OTHER
NEW YORKERS.

IF A FLEA WAS A HUMAN BEING, IT
WOULD BE ABLE TO JUMP 1000 FEET
STRAIGHT UP IN THE AIR.

MORE THAN TWO-THIRDS OF ALL PEOPLE, WHO HAVE REACHED 65 OR OLDER, ARE STILL LIVING.

YOU WILL INHALE ABOUT 44 POUNDS OF DUST DURING YOUR LIFE.

BABIES ARE ALWAYS BORN WITH BLUE EYES.

MORE THAN 8,000 NON-FUNCTIONING SATELLITES ARE CIRCLING AROUND THE EARTH.

IN 1988, A POODLE FELL FROM A HIGH-RISE BUILDING IN BUENOS AIRES AND KILLED THREE PEOPLE. ONE GOT THE POODLE ON HIS HEAD, A BUS HIT THE OTHER AND THE THIRD HAD A HEART ATTACK, WATCHING IT ALL.

BILL WYMAN, FORMER BASS GUITARIST FOR *THE ROLLING STONES*, DATED MANDY SMITH, WHOM HE LATER MARRIED, WHEN SHE WAS ONLY THIRTEEN. SEVEN YEARS LATER STEPHEN, WYMAN'S SON, MARRIED MANDY'S MOTHER. THIS MAKES STEPHEN A STEPFATHER TO HIS OWN STEPMOTHER.

UNSOLVED MYSTERIES

IF YOU ATTEMPT TO FAIL AND SUCCEED, WHAT HAVE YOU REALLY DONE?

WHY IS 'TIME' WHEN TRAFFIC MOVES SLOWLY, CALLED 'RUSH HOUR'?

HOW FAST IS THE SPEED OF DARK?

IF BARBIE IS SO POPULAR, WHY DO YOU HAVE TO BUY HER FRIENDS?

WHAT HAPPENS IF YOU ARE
SCARED HALF TO DEATH, TWICE?

HOW CAN A HOUSE BURN UP
WHEN IT'S BURNING DOWN?

IF YOUR VACUUM CLEANER SUCKS,
IS THAT A BAD THING?

HOW CAN YOU TELL IF A SMURF IS
CHOKING ON SOMETHING?

IF A WORD IN THE DICTIONARY IS MISSPELLED. HOW WOULD YOU KNOW IT?

IF YOU EXPECT THE UNEXPECTED, IS THE UNEXPECTED THEN EXPECTED?

IF YOU TAKE A PICTURE OF CHEESE,
WHAT DOES IT SAY?

DOES A TEA DRINKER
HAVE COFFEE BREAKS?

WHY DO THEY REPORT
POWER OUTAGES ON TV?

WHY DO YOU PRESS HARDER ON THE
REMOTE CONTROL BUTTONS WHEN
THE BATTERIES ARE DEAD?

IF IT'S +-0 DEGREES CELSIUS IN THE EVENING AND IT WILL BE TWICE AS COLD THE NEXT MORNING, HOW COLD WILL IT THEN BE?

WHY IS THE WORD "ABBREVIATION" SO LONG?

HOW COME A MAN CAN BELIEVE THAT THERE ARE 400 BILLION STARS, BUT IF YOU TELL HIM THAT THE PAINT IS WET, HE'S GONNA GO AHEAD AND TOUCH IT?

HOW COULD SOMEONE BE SO CRUEL AS TO PUT AN "S" IN THE WORD "LISP"?

WOULD A FLY WITHOUT WINGS BE CALLED A WALK?

WHY DOES YOUR HAIR TURN LIGHT IN THE SUN WHEN YOUR SKIN GETS DARKER?

WHY CAN'T GIRLS PUT THEIR MASCARA ON WITH THEIR MOUTHS CLOSED?

HOW COME YOU NEVER SEE THE
HEADLINE "PSYCHIC WOMAN
WINS LOTTERY"?

IN WINDOWS 98, HOW COME YOU
HAVE TO PRESS THE "START"
BUTTON TO TURN THE
COMPUTER OFF?

WHY ISN'T THERE MOUSE
FLAVOURED CAT FOOD?

WHEN DOG FOOD HAS A "NEW AND
IMPROVED TASTE", WHO TASTED IT?

IF THE BLACK BOX IN AIRPLANES IS UNBREAKABLE, WHEN THEN DON'T THEY BUILD THE WHOLE PLANE OUT OF THAT MATERIAL?

WHY DON'T SHEEP SHRINK WHEN IT RAINS?

IF IT'S SO SAFE TO FLY, WHY IS THE AIRPORT CALLED "TERMINAL"?

WHEN GIVING A LETHAL INJECTION IN AN AMERICAN PRISON, WHY IS THE NEEDLE FIRST STERILIZED?

WHAT HAPPENS IF YOU TRAVEL AT THE SPEED OF LIGHT, THEN TURN YOUR HEADLIGHTS ON?

ARE THERE HUMAN GUIDES FOR BLIND DOGS?

WHY DO THEY SAY FREE GIFT? AREN'T ALL GIFTS FREE?

IF A SCHIZOPHRENIC PERSON THREATENS TO KILL HIMSELF, IS THAT CONSIDERED A HOSTAGE SITUATION?

IF YOU END UP IN A LIFE CRISIS
WHILE PLAYING HIDE AND SEEK,
DO YOU AUTOMATICALLY LOOSE
BECAUSE YOU CAN'T FIND
YOURSELF?

WHO TOWS THE TOW TRUCK
WHEN IT BREAKS DOWN?

IF OLIVE OIL COMES FROM OLIVES,
THEN WHERE DOES BABY OIL
COME FROM?

ANOTHER WORD FOR SYNONYM?

WHY IS IT CALLED MISSILE? SHOULDN´T IT BE CALLED HITTILE INSTEAD?

DOES WATER FLOAT?

WHAT HAPPENS TO THE WHITE WHEN THE SNOW MELTS?

WHY IS A BOXING RING SQUARE?

WHY DO PEOPLE SCREAM "HEADS UP!" WHEN SOMETHING IS COMING TOWARDS YOU? DO THEY WANT YOU TO GET IT IN YOUR FACE?

WHY DOESN'T GLUE STICK TO THE INSIDE OF THE BOTTLE

IF YOU PLANT BIRD SEED?

BLA BLA: 600 Incredibly Useless Facts About Celebs
91-85449-12-1, Humor/Pop Culture, $ 9.95/Paper
Strange and interesting facts about all your favorite celebrities.

BLA BLA: 600 Incredibly Useless But Fantastic Quotes
91-85449-13-X, Humor/Pop Culture, $ 9.95/Paper
This book contains the best quotes from world famous actors,
scientist, politicians, billionaires, supermodels and many more.

The Student Cookbook
200 Cheap and Easy Recipes for Food, Drinks and Snacks
91-85449-11-3, Humor/Cooking, $ 9.95/Paper

The Mission
The Change-Your-Life Game
91-85449-06-7, Humor/Games, $ 9.95/Paper
This book is a real-life game that may change your life!

The Macho Man's Drinkbook
91-85449-08-3, Humor/Cooking, $ 19.95/Paper
The Macho Man's Drinkbook contains more than 150 recipes of
the most popular drinks accompanied by 60 color photos of
exotic and beautiful, topless women.

MORE FROM NICOTEXT

Ultra Modern History
The History of Sitcoms, Porn, Microwaves and Skateboards
ISBN: 91-85449-07-5, Humor/Pop Culture, $ 9.95/Paper
Let the old folks read the old history books because this is
history for the new generation.

The Pet Cookbook
Have your best friend for dinner
91-974883-4-8, Humor/Cooking, $ 14.95/Paper
Domesticated Delicacies from Around the World

The Pornstar Name Book
The Dirtiest Names on the Planet
91-974883-2-1, Humor, $ 14.95/Paper
The coolest hardcore names in the business
Rename your lover, or your pet, your car or the stupid
person at work in the nom de plume of a pornstar!

Confessions
Shameful Secrets of Everyday People
91-974396-6-5, Humor, $ 9.95/Paper
Eavesdropping in the Confessional.

The World's Coolest Baby Names
A Name Book for the 21st Century Parent
91-974883-1-3, Pop Culture, $ 7.95/Paper
A perfect name guide to spice up any baby shower name game.
Baby names aren't handed down anymore, and the coolest name
are as much from pop culture as from the Bible.

Dirty Movie Quote Book
91-974396-9-X, Humor/Film, $ 9.95/Paper
Saucy Sayings of Cinema.
With over 700 saucy, sexy quotes from the funniest and
most sordid films ever produced. A movie quiz game in a book.

Cult Movie Quote Book
91-974396-3-0, Humor/Film, $ 9.95/Paper
A Film Buff's Dictionary of Classic Lines.
Over 700 memorable, movie quotes

The Bible About My Friends
91-974396-4-9, Humor, $ 9.95/Paper
Things You've Always Wanted to Know
But Have Been too Scared to Ask.